THE UNIVERSITY OF KANSAS

FRANKLIN D. MURPHY LECTURE SERIES

SPENCER MUSEUM OF ART

THE UNIVERSITY OF KANSAS, LAWRENCE

in association with

UNIVERSITY OF WASHINGTON PRESS

SEATTLE AND LONDON

THE BODY IN TIME

Figures of Femininity in Late Nineteenth-Century France

TAMAR GARB

*The Murphy Lecture Series is sponsored by the Spencer Museum
of Art, the Kress Foundation Department of Art History at the
University of Kansas, and the Nelson-Atkins Museum of Art.
The lectureship was established in 1979 through the
Kansas University Endowment Association in honor of
former chancellor Dr. Franklin D. Murphy.*

Published by the University of Washington Press for the
University of Kansas Franklin D. Murphy Fund, with additional
support from the Office of the Provost, University of Kansas
Printed in the United States of America
Design by Ashley Saleeba
12 11 10 09 08 5 4 3 2 1

Spencer Museum of Art
The University of Kansas
1301 Mississippi Street
Lawrence, KS 66045-7500 USA
www.spencerart.ku.edu

University of Washington Press
P.O. Box 50096
Seattle, WA 98145 USA
www.washington.edu/uwpress

Library of Congress Cataloging-in-Publication Data
can be found at the back of the book.

The paper used in this publication meets the
minimum requirements of American National Standard
for Information Sciences—Permanence of Paper
for Printed Library Materials, ANSI Z39.48-1984.

CONTENTS

THE BODY IN TIME

INTRODUCTION

THE INVITATION FROM THE UNIVERSITY OF KANSAS TO DELIVER the Franklin D. Murphy lectures in Lawrence and Kansas City in spring 2005 provided me with the opportunity to think again about two kinds of picture-making that have long interested me: portraiture and modern life painting. Each mediates the figure of Woman via distinctive pictorial conventions, affected by and altered through the technologies and ideologies of modernity and the demands of genre. In the following case studies, I look at two very different late nineteenth-century projects of female representation: one deals with anonymous female workers, the young ballerinas at the Paris Opera, while the other foregrounds privileged individual women, self-assured artists transgressing gender conventions; one focuses on the generic and the typical, while the other looks for the distinctive and the special. In both cases, the representation of women's work is at stake; whereas the ballerina's public display of flesh positioned her as a sexual commodity, the emancipated woman

was desexed and defeminized. Class, gender, power, and agency play out in different ways in these arenas, via differing pictorial languages.

The representation of scenes of everyday life was not a phenomenon invented in nineteenth-century Paris. Genre painting had long concerned itself with such themes, although traditionally clothing its depictions in moral and didactic messages. What was new in late nineteenth-century France was the attempt to show life as it was, without inviting sympathy, empathy, or moral instruction. The mere act of "truthful" representation, "authentic" self-expression, and "impartial" recording accrued ethical connotations in the prevailing context of positivism, empiricism, and the new scientism. It was not necessary to convert, persuade, or even move the viewer: realists were instead required to reveal and record actual social relations via the description and depiction of their principal protagonists and the scenes they occupied. The resultant pictorial representations masked the phantasmatic investments of their producers. While the female body was a crucial vehicle for the demonstration of skills of observation and recording, it was at the same time subject to an erotically charged and libidinal looking that exceeded the detached protocols of realist reportage. The sexually available, partially clothed, commodified corpus of the working woman—whether dressed in the guise of prostitute, dancer, or demi-mondaine—functioned as the crucial representational topos of modernity because it could appear to demonstrate impartial modern methods of transcription (realism's alibi) at the same time that it embodied the carnal materiality of modern metropolitan life.

Degas' extraordinary representations of the ballet can be understood in this context. His early essays on this theme have come to stand for a realist refusal of the abstractions and idealizations of history painting, in which he was schooled, as well as the manifestation of a modern sensibility mobilized in the portrayal of modernity's figural archetype: the semi-clothed, fleshly performer of a debased but highly desirable form of public entertainment. Degas' later, more generalized reworkings of dancers in numerous compositions appear less concerned with the specificities of social context or legible markers of identity than with evocative surfaces and painterly effects. But whether we are witnessing realist views of backstage ballerinas or suggestive symbolist essays in color and light, it is, in either case, the figure of femininity that functions as a vehicle, both for the detached scrutiny of the realist's gaze and the ethereal fantasy of the symbolist's reverie. Whereas realism invites viewers to believe in the veracity of the vector as an agent whose subjectivity can be imagined and reconstructed, symbolism has no such delusions.

It wears its partiality on the surface, its figures no more than figments of the imagination, captured and constructed in pastel and paint.

Portraiture too negotiates a path between description and desire. In particular, portraits of women have historically functioned as repositories of fantasy, whether that of their authors or their viewers. My second case study examines a group of portraits of independent women, themselves engaged in making meaning, both in their own self-fashioning and in the images they adumbrated on canvas. Going against the grain of traditional representations of seductive femininity, these figures can be understood in relation to the new social and sexual constructs that emerged as symbolist theories of art gained prominence. For the symbolists, Woman came to stand (amongst other things) for the otherworldly, the insubstantial, and the effete, qualities that could be metaphorized in female figures or displaced onto a feminized surface.

In this context, the bold claims made by social campaigners, suffragettes, and female professionals rankled. For women artists, writers, and critics, symbolism could involve the silencing of women in the interests of the idealization of the feminine. Portraits of bold protagonists representing women's autonomy and agency could not, therefore, comfortably conform to the traditional topoi of seductive and sensual femininity. Nor could they invoke the displacement of sexuality onto surface and space, as the most adventurous and ambitious of the symbolists were doing.

By the late 1880s and 1890s, "realisms" proliferated. No longer representing the dangerous and subversive attitudes of the artistic radicals of the late 1850s to early 1870s, realism had become the standard aesthetic modality of the Third Republic, standing for the rational and democratic values of a newly enfranchised political establishment. At the same time, realist strategies continued to be mobilized by social reformers and political campaigners to describe the world of social relations. It is not surprising that many educated women, long seeking to establish their own rationality and intelligence, their capacity to function as citizens and peers despite their continuing exclusion from political engagement or enfranchisement, would come to use some of these strategies in their self-representation.

The realism deployed by women artists in the portraits they painted of themselves and their peers was unlike that invented and invoked by Degas, whose manifest presence had always been part of the materiality of his practice. By the time Anna Klumpke, Rosa Bonheur, and Anna Bilinska-Bohdanowiczowa were creating their groundbreaking images of modern

female professionals, Degas had discarded his prior engagement with the minutiae of daily encounters in the social space of the studio or stage, favoring instead the distillation of experience as pure pictorial effect. The figures of femininity in his later dance paintings now functioned primarily as vehicles for a feminization of the surface as a whole. This idea was not new, even if its manifestation in symbolist works took a new form. Portraitists of women had, since the High Renaissance, found ways to eroticize the surface of the picture as a seductive analogue to the figures it adumbrated. Women artists in the late 1880s and 1890s had, therefore, to negotiate a double displacement, avoiding both the conventions enshrined in traditional portraiture, and the new rhetorical gestures of symbolism.

Realism's afterlife persisted, even as symbolism's newly formulated abstractions produced their own progeny. If female agency was to be asserted, realism rather than idealism (new and old) seemed to provide the appropriate vehicle. The figure of femininity as vehicle, though, remained central to both aesthetic positions. Whether embodying the distillation of the modern in the spectacular labor of the ballerina, or providing the figural pretext for a meditation on the libidinal dream-space of Art; whether conceived under the sign of mimetic transcription, or as the idealized heroine of a new social dispensation, pictures of women served modern artists well. Following reigning and emergent aesthetics and interests, they reworked their feminine figural prototypes according to the formal and technical imperatives of their affiliations: personal, political, and pictorial.

I am grateful to Linda Stone-Ferrier, chair of the University of Kansas Kress Foundation Department of Art History, Saralyn Reece Hardy, director of the Spencer Museum of Art, and Marc Wilson, director of the Nelson-Atkins Museum of Art, for the invitation to deliver the Murphy lectures in Lawrence and Kansas City. I thank my hosts, professors Marni Kessler and David Cateforis, organizers of the Murphy Seminar in which I participated, for the generous hospitality they showed me during my stay in Lawrence. I will never forget my outings to the prairies and the downtown art galleries of Kansas City. I remember fondly the wonderful barbecues, feasts, and festivities shared with colleagues and students. The graduate students in the Murphy Seminar worked willingly and generously with me over an intense two-week period and we were all transformed and enriched by the experience. I am grateful also to Maud Humphrey in the art history department for her administrative assistance in procuring the illustrations for this publication.

TEMPORALITY & THE DANCER

HISTORY SHAPES THE BODY. CLOTHED IN CONVENTION AND shaped by time, the body's forms of address, demeanor, and deportment are the product of society: changeable, contingent, and contested. Made in representation, a matter of letters and lines, sounds and shapes, the body performs its historicity through form, registering its time-bound specificity in the images and icons produced by culture.

For a nineteenth-century realist like Edgar Degas, working in Paris in the 1870s and 1880s, it was the specificity of the human body in its social situation that painting and drawing could best register and reveal. Less interested in the minutiae of facial expressions or physiognomic details than a figure's characteristic attitude or pose, Degas surveyed the metropolis and its scenes of public entertainment like an ethnographer, focusing on the generic and typical attitudes of his cast of characters in order to reveal their social identities and situations rather than their individual idiosyncrasies. Those he would leave for portraiture, of which he was both a practitioner and an

advocate. In his scenes from modern life, however, while Degas represented specific "events" and "moments," he also inscribed and thematized relations between audience and actor, setting and context, artist and viewer.

Nowhere was this more productive than at the ballet, the modern locus of sexual exchange and public display, and a site explored repeatedly by Degas in paintings, drawings, and prints.[1] Central to his interest in the opera house and its occupants were the young ballerinas engaged in their daily routines, repetitive exercises, and public performances. Studied individually or in groups, on stage or behind the scenes, they became the focus of his artistic attention. Whether fidgeting with a bow, stretching awkwardly, yawning, scratching, flexing a foot, or fastening a shoe, Degas' dancers take up their positions as members of a chorus, a group moving to the orchestrated rhythm of its time, conforming to its pulsating beat and dynamic, repetitive strains. Arranged in groups or individually posed, in rehearsal rooms, as in *Dance Studio at the Opera on the Rue Le Peletier* (1872), or on the stage, as in *The Rehearsal of the Ballet on Stage* (1874), the dancers perform under the direction of the ballet master, the imposing sound of the orchestra, and the watchful eyes of the wealthy men who are their paymasters (figs. 1 and 2). The carefully observed poses, gestures and attitudes of Degas' figures articulate the tensions and pressures as well as the pleasures of modern urban experience. It was this pulse, this social dance, that Degas, the realist, managed to picture. "He is an observer, a historian perhaps," wrote the critic Paul Mantz in 1877, commenting on the way in which Degas penetrated to what he described as, "the pain beneath the tinsel," the real social interactions, physical exertions, and prosaic settings that were concealed by the glitzy surface of public performance.[2]

Not for Degas the synchronized perfection and idealized beauty of the romantic ballerina of a previous age. Such was the vision of the ballet promoted in countless lithographs and reproductions circulated throughout Paris in the nineteenth century, helping to constitute the prevailing myth of ballerinas as delicate, otherworldly creatures, poised in perfect formation in an ethereal universe devoid of time or place. In these images, the dancers' bodies lacked specificity or detail.[3] Each conformed to the ideals of grace and perfection that the spectacle of the ballet produced and the figure of the female dancer embodied. Often posed around the principal dancer "en pointe," itself an early nineteenth-century invention which, according to dance historian Lynn Garafola, "ushered women into a realm of perpetual maidenhood, an idealised version of the separate female sphere,"[4] the dancers were habitually

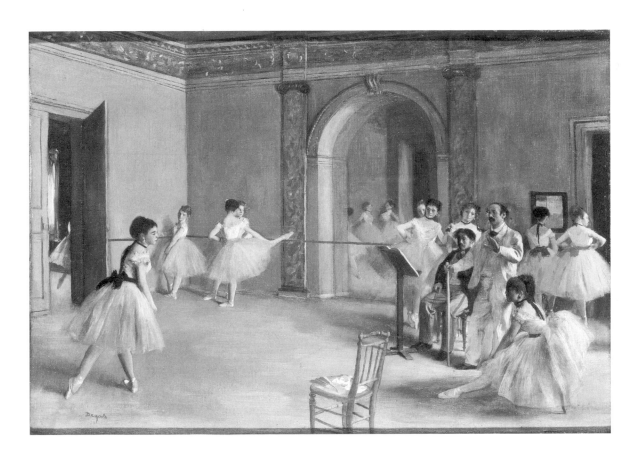

1 Edgar Degas, *Dance Studio at the Opera on the Rue Le Peletier*, 1872
Oil on canvas, 32 × 46 cm
Musée d'Orsay, Paris. Photo credit: Réunion des Musées
Nationaux / Art Resource, New York; reference ART151102

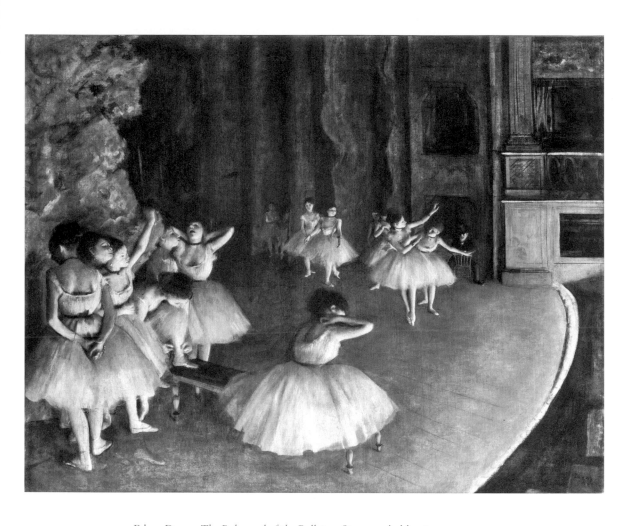

2 Edgar Degas, *The Rehearsal of the Ballet on Stage*, probably 1874

54.3 × 73 cm

Musée d'Orsay, Paris. Photo credit: Scala / Art Resource, New York

clad in virginal white, the characteristic costume of the "ballet blanc," which constructed the female body as more spirit than flesh, more abstract than real.

While Degas' contemporary, Pierre-Auguste Renoir, was content to gloss over setting and social identity, creating out of his floating young dancer of 1874 "a kind of fairy molded in earthly forms," the realist Degas located his models within the circuits of production and exchange through which their social identity was constituted (fig. 3).[5] Often accompanied by the men who framed their existence—musicians, patrons, customers, teachers—and the women who supervised and chaperoned them, Degas' dancers are seen to act out their roles within a specific social milieu. Not for him the indeterminate space and subtle suggestiveness of Renoir's pubescent ballerina, isolated in a carefully orchestrated painted field of echoing tones and color harmonies. In contrast, Degas' *Dancer in Her Dressing Room* (1879) is characteristically pictured behind the scenes, in the arena of her own metamorphosis from a somewhat slovenly young girl into an object of public fascination and admiration (fig. 4). The flesh and blood dancer seems to assume her role before our eyes. Posed in front of the mirror, attending to her hair, and surrounded by discarded garments strewn casually on the floor, she is illuminated by the artificial light placed in front of her, left underarm and elbow tantalizingly reflected as a fleshy, pink fragment in the mirror. Garishly lit so that her painted lips stand out against the powdered pallor of her skin, this is a figure fabricated through artifice and adornment, and Degas offers us the space of her transformation. No idealized abstraction or otherworldly goddess, this young woman, with her rouged mouth and exposed limbs and chest, is a *Parisienne,* made and made-up in the concrete circumstances of the backstage boudoir.

In keeping with his rejection of the notion of the dancer as an idealized abstraction embodying classical notions of timeless beauty and universal truth, Degas also rejected the construction, beloved of neoclassical and academic artists, of the artist as the invisible, external orchestrator of a depicted scene. If romantic ballet aimed to produce the illusion of effortlessness, the result of an expression of the essence of femininity turned into spectacle and embodied by the ballerina, academic art could be described as having sought a similar goal—that its labor be occluded and obliterated by the final effect of the work. Degas uncovered the labor of dance and the labor of art, creating an equivalence between them on the surface of the artwork. In so doing, Degas reconfigured the body in social space and historical time while registering his own corporeal presence as witness in the tactile surfaces and

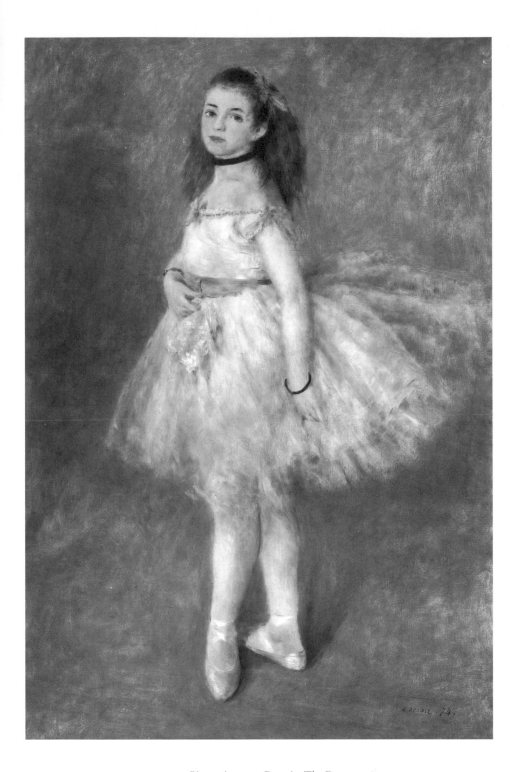

3 Pierre-Auguste Renoir, *The Dancer*, 1874
Oil on canvas, 142.5 × 94.5 cm
Widener Collection, National Gallery of Art, Washington, D.C.

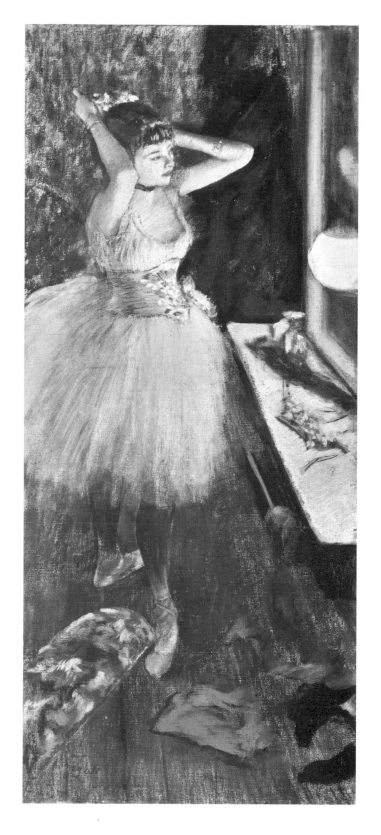

4 Edgar Degas, *Dancer in Her Dressing Room*, 1879
Pastel on canvas, 87.9 × 40.3 cm
Cincinnati Art Museum; bequest of Mary Hanna; acc. no. 1956.114

scumbled facticity of his works, leaving his mark on his opaque and densely worked canvases without smoothing over or erasing his touch.

Degas created highly individuated compositions by constructing particularized, unorthodox viewpoints and angles of vision. Neither neutral observer nor fictive disembodied spectator, Degas inscribed his own singular perspective on the events of his time by adopting a view from the sidelines, throwing into disorder the orchestrated frontality of the conventional auditorium vantage point. In a pastel like *Dancers at the Old Opera House* (1877), for example, Degas fabricated a putative position from which to look and depict, ostensibly placing himself above the stage and looking down from the wings (fig. 5). In a work such as *Ballet Scene from Meyerbeer's Opera "Robert le Diable"* (1876), he seems to occupy the lower perspective of the musicians in the orchestra pit (fig. 6). In each case, the singularity and veracity of viewpoint was part of the realist fiction to which he was committed. Although Degas was neither seated below the stage with his friends in the orchestra nor suspended above the stage on a platform in the wings when actually executing his pastels and paintings, his works nevertheless presuppose just such a viewpoint. The fiction serves to endorse the illusion of presence and presentness that Realism entails. Realist time is always the present, and its rhetorical alibi is the putative presence of the artist as witness.[6]

Research into the conditions of production of works like these, however, reveals the artifice that was at their source. *Dancers at the Old Opera House*, for example, was executed some years after the ballet had ceased to be held at the old theatre in the rue Le Peletier, which the image evidently depicts. Executed in pastel over monotype, the work could not predate Degas' invention of monotype in 1876. And yet the architectural detail of cornices, pilasters, and the decoration of the "loges" (the private viewing boxes that are clearly depicted) confirm the work's setting as the stage and auditorium of the building that had been destroyed by fire in 1873.[7] Placed high above the stage, behind the shadowy pilaster that forms the boundary between the space of the performers and that of the orchestra and audience, Degas invents for himself a privileged bird's-eye view which allows him to picture fragments of all components of this social scene: the legs and the chorus of dancers together with a sketchy rendering of their hands, heads, and torsos; the dark mass of the orchestra punctuated by flesh tones that stand for hands and faces; and the animated presence of the audience ensconced, across the way, in their private boxes, a flurry of gesture, movement, and agitated paintwork. United on the plane of the picture, the participants of the social scene are signified by touch and texture, smudged, smeared, and stroked onto the paper's surface.

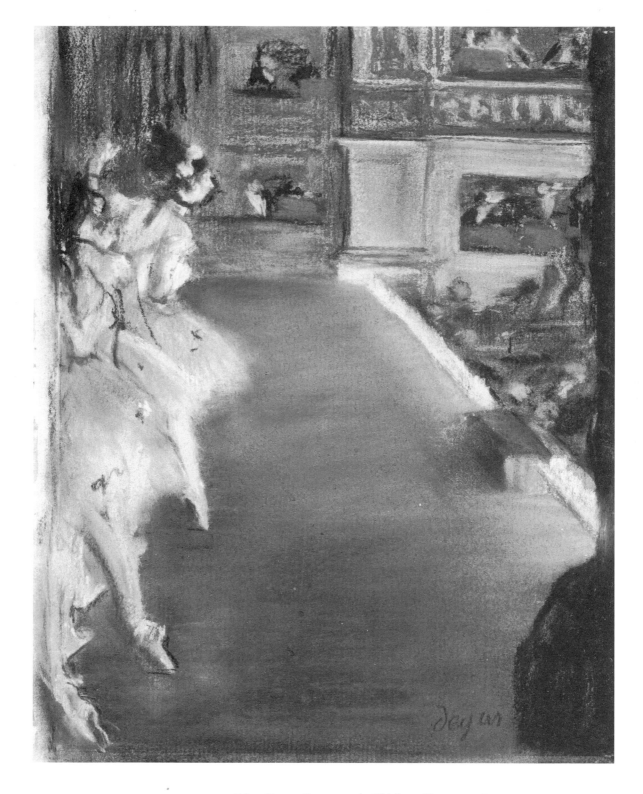

5 Edgar Degas, *Dancers at the Old Opera House*, ca. 1877
Pastel over monotype on laid paper, 21 × 17 cm
Ailsa Mellon Bruce Collection, National Gallery of Art, Washington, D.C.

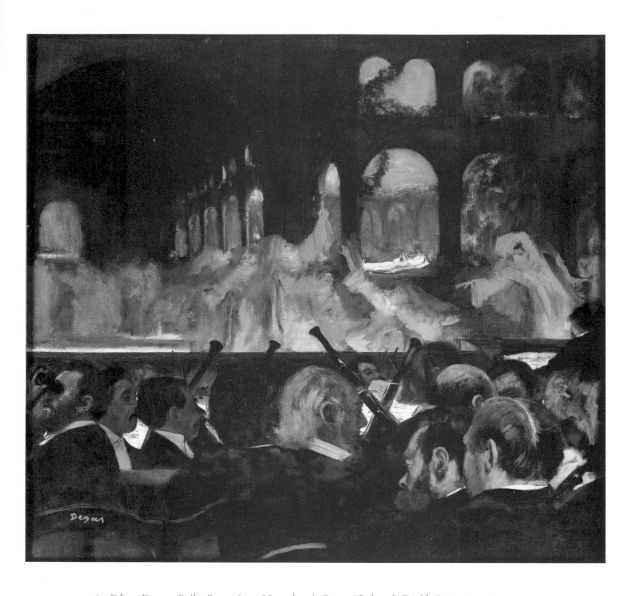

6 Edgar Degas, *Ballet Scene from Meyerbeer's Opera "Robert le Diable,"* 1876
Oil on canvas, 76.6 × 81.3 cm
Courtesy of the Trustees of the Victoria and Albert Museum, London

This tactile richness, which registers the hand of the artist, appears to testify to his presence, the time of making and time of witnessing seeming to unite on the picture plane.

But the relationship between the scene depicted and the act of execution was much more artificial and disjointed than the rhetoric of realism would have us believe. Degas could not possibly have used *this* medium to witness *this* event (at the rue Le Peletier premises), except as an imaginary space redrawn from notes and recollections, made piecemeal from drawings and sketches some years after the ballet had moved into its new premises. It is this mobilization of memory and recall that leads to the repetitions at the heart of Degas' dance project. Imprinted in his mind and on the pages of his sketchbooks and canvases was a lexicon of shapes and forms which formed his basic pictorial vocabulary of the dance and which was continuously being added to and altered. Eventually, the physical space of the dance would become an entirely imagined one for the aged Degas, but the cast of characters, the repertoire of poses and positions that peopled it, would continue to be animated and filled, only to be recycled and repeated in a variety of pictorial forms.

This capacity for imaginary reconstruction was already present in the 1870s. Even then, Degas the historian remade history through memory, offering a partial distillation and concentration of immediate experience, conceived pictorially, rather than as an accurate or neutral recording of it. *Dancers at the Old Opera House* populates a ruined space, site of the birth of the romantic ballet (by then in decline) and the familiar theatre of Degas' youth, with imaginary figures, themselves fragments and figments of a phantasmatic encounter between the artist and the bodies of the young female performers with which he was obsessed. Depicting the past as if in the present, Degas' retrospective realism depended on the recycling of these figures and body parts in different pictorial scenarios, constituting a kind of compulsive choreography in which the picture plane functions as the setting for an imaginary encounter in the present.[8]

Central to Degas' fascination with the ballet was the figure of the female dancer. Throughout his career, Degas turned to the ballerina as the perfect model for studies from life. Graphite drawings from 1872 and 1873 form part of a private archive of poses and positions to which he would return repeatedly (fig. 7). In such early drawings, the traditional rectangular grid is superimposed over the body of the dancer, allowing the figure to be accurately scaled up onto other surfaces and recycled in different contexts. It provided, too, a rectilinear framework for the initial transcription of the world onto paper. The grid seems to measure and mark out the body at the same time as

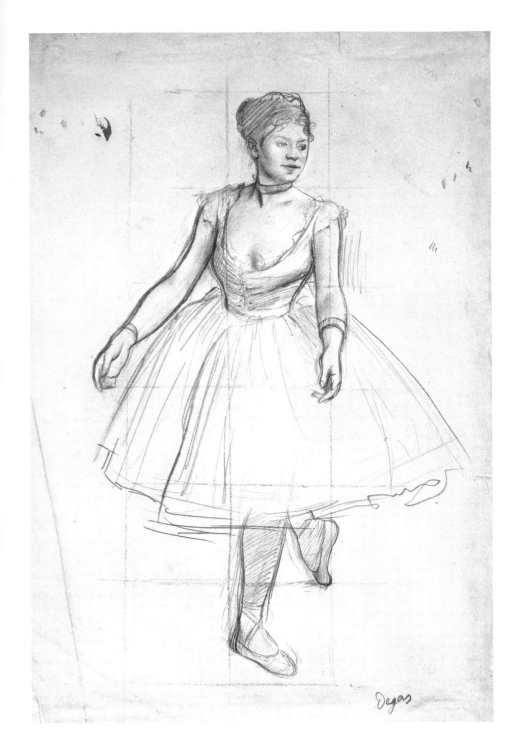

7 Edgar Degas, *Ballet Dancer in Position Facing Three-Quarters Front*, ca. 1872–73
Graphite, prepared black chalk, white chalk, and touches of blue-green pastel
on pink wove paper, squared in prepared black chalk, 41 × 27.6 cm
Courtesy of the Fogg Art Museum, Harvard University;
bequest of Meta and Paul J. Sachs; acc. no. 1965.263

it echoes the flat rectilinearity of the paper. A checkerboard overlaying the figure, the grid dramatizes the process of transcription while making manifest its artifice by bearing witness to the systems by which "nature" may be "recorded." But the graphite grid is, itself, no detached mathematical structure. Registering the hand that orders the seen world into a depicted one, the lines of the grid fade and appear, falter and halt, emphasize and efface, so that its identity as a series of marks exceeds its function as a mere instrumental tool. Apparently detached and scientific, the shaky line of the grid appearing and disappearing over the dancer's legs and torso frames and fragments the body into piecemeal units that are psychically and technically manageable. The searching contour lines of the body, the hatched lines of the shading, the exploratory squiggles suggesting clothing and hair—all these intersect and interact with the woven pattern of the grid that overwrites or underscores the figure with handmade hesitancy.

Some twenty to thirty years later, Degas would still be producing charcoal studies of dancers with raised arms, seen from side, back, and front; of nude dancers tying their shoelaces, posing with legs splayed and genitals emphasized; and of standing figures assuming their customary positions in the space of the studio. These drawings evidence Degas' continuing fascination with the body of the ballerina, to which he would turn throughout his life. It was, above all, the semi-naked figure of the female dancer that fueled his imaginative encounter with the opera as a social space in his early work, and it was her body, traced and retraced repeatedly, that animated his continued engagement with the pictorial possibilities of dance in the later works.

Degas hardly ever painted male dancers, a breed rendered almost extinct in the hypersexualized space of the romantic ballet. The *danseur* had come to be regarded as an effeminate aberration, and male roles were usually played by female travesty dancers. Statements made by Jules Janin, a well-known critic and literary figure of the mid-century, illustrate just how incongruous the figure of the male dancer had become.[9] Writing in 1840, he states:

> The *grand danseur* appears to us so sad and so heavy! He is so unhappy and so self-satisfied! He responds to nothing, he represents nothing, he is nothing. Speak to us of a pretty dancing girl who displays the grace of her features and the elegance of her figure, who reveals so fleetingly all the treasures of her beauty. Thank God, I understand that perfectly, I know what this lovely creature wishes us, and I would willingly follow her wherever she wishes in the sweet land

of love. But a man, a frightful man, as ugly as you and I, a wretched fellow who leaps about without knowing why, a creature specially made to carry a musket and a sword and to wear a uniform. That this fellow should dance as a woman does—impossible. That this bewhiskered individual who is a pillar of the community, an elector, a municipal councillor, a man whose business it is to make and above all unmake laws, should come before us in a tunic of sky-blue satin, his head covered with a hat and waving a plume amorously caressing his cheek, a frightful *danseuse* of the male sex, come to pirouette in the best place while the pretty girl stands respectfully at a distance—this was surely impossible and intolerable, and we have done well to remove such great artists from our pleasures. . . . Today . . . woman is queen of the ballet. . . . Today the dancing man is no longer tolerated except as a useful accessory.[10]

Nineteenth-century ballet comes, therefore, to be identified with "femininity," standing for its alleged mystique, "elusiveness," and "unattainability," and it is the *danseuse* whose body bears the responsibility of representing that femininity to the culture. Yet, the ballerina was not just a vehicle for the symbolic expression of femininity, nor was she only a cipher for an ethereal fantasy of a world transported from the tensions of modernity. The female dancer functioned also as a sexual commodity.[11] It was her semi-naked body that attracted audiences to the theatre, and it was at her that most men came to gawp when they bought their tickets or paid their annual subscriptions. Faced with the possibility of declining audiences and reduced profits, nineteenth-century entrepreneurs knew that adding set pieces for the *corps de ballet* would pull in the punters and guarantee crowds. There was money in women's bodies and the opera was the perfect place for capitalizing on the legitimate display of semi-naked female flesh.

Degas, like his forebears so brilliantly satirized by Daumier in the 1850s and Cham in the 1860s, was fixated on the female dancer (fig. 8). But the vulgar audiences pilloried in such images are positioned in the auditorium, lecherously devouring the spectacle of semi-naked female performers on stage, whereas Degas obsessively fractured and fragmented the totalizing vision by which they were captivated and placed the spectators, musicians, and minders on display together with the female performers. Not only did Degas assume unorthodox viewpoints and angles in his compositions, he also pictured the act of viewing itself as awkward and embodied rather than ideal or abstracted. In an extraordinary pastel of 1884, *Ballet from an Opera Box,*

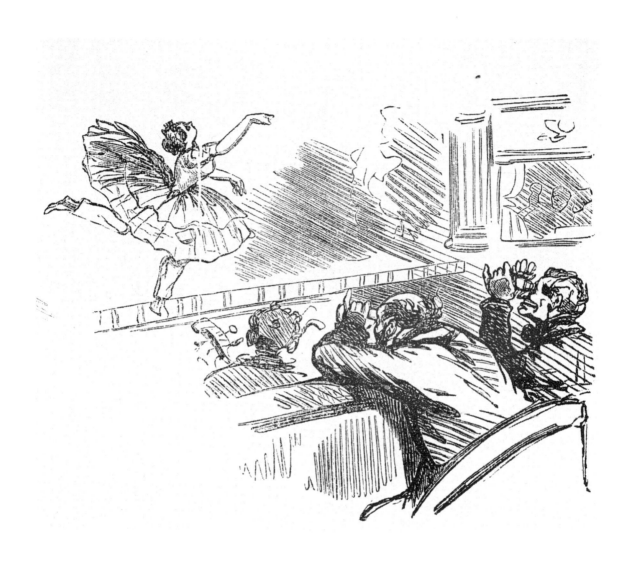

8 Cham, "Les Lorgnettes," *L'Illustration*, 21 April 1860

Degas positions a female viewer, binoculars in hand, in a loge, so that the semi-circular shape of her fan, primary signifier of her femininity, reads as an inverted echo or double of the foreground dancer's tutu, which it partially obscures (fig. 9). As elsewhere in his oeuvre, Degas' picture seems to demonstrate the very fragmentary nature of vision, while his careful orchestration of bodies only partially seen or fleetingly glimpsed points to the erotic dimension of looking, its stolen pleasures, private passions, and perverse and fetishizing operations. No one figure is represented here in her entirety. Where the cut-off viewer in the foreground serves as a *repoussoir* framing device, as well as a signifier of fashionable femininity, the central ballerina, the only illuminated figure in the picture and the focus of attention, is shown from above, her face in the shadows, her legs invisible, her body flattened and truncated as if squashed against the tilting floor. Behind her, the corps de ballet is pictured as an array of legs and arms divided by identical colored costumes—so many repeated body parts providing orchestrated tinted and tonal accents against the dull brown ground. Punctuating the surface with color and light, the limbs and torsos of the dancers function as disembodied decorative markers. Femininity comes to serve as the sign for surface adornment, artifice, and the aesthetic, and a subtle conflation of sexual and aesthetic pleasures is conveyed by the repetition and orchestrated harmonies created by a rhythmic iteration and reiteration of overdetermined female body parts.

Signified either in her entirety or through fragments—an arm reaching into the composition, a lone leg, or a torso glimpsed at an edge—the ballerina in Degas' oeuvre reads as a distilled representation of the transformation of the nineteenth-century female body into spectacle, and the fragmentation of the modern body into component parts.[12] The youthful dancer's body, engaged in her regular routines, is the focus of a prurient and sexualized gaze that invests certain body parts, legs in particular, with a powerful erotic charge. Recycled and replayed in various contexts, the body of the dancer is subject to repetition, variation, and recontextualization, its gestures and movements replayed and rehearsed in Degas' pictures as in the performative protocols of the ballet itself.

Legs were the primary signifier of the ballerina. Glimpsed from beneath a backdrop, as in an oil painting from the mid-1870s, where they stand metonymically for a bevy of ballerinas waiting behind the scenes, pairs of pink calves and feet offer the promise of female flesh ready-packaged as fetish object (fig. 10).[13] It was only at the opera that a proliferation of exposed legs, conventionally draped or covered, were on public view. The tightly clad calves and orchestrated turnouts and points of the female dancers' satin-slippered

9 Edgar Degas, *Ballet from an Opera Box*, ca. 1884
Pastel on paper, 66 × 50 cm
The John G. Johnson Collection, Philadelphia Museum of Art

10 Edgar Degas, *Yellow Dancers (in the Wings)*, 1874–76
Oil on canvas, 73.5 × 59.9 cm
The Art Institute of Chicago; gift of Mr. and Mrs. Gordon Palmer,
Mr. and Mrs. Arthur M. Wood, and Mrs. Bertha P. Thorne

feet were as much the attraction of the ballet as the performance itself. With their dresses shortened, the better to show off their "lovely legs and calves," and their "charming slippers so tight and well-fitted," wrote one critic from the mid-1870s, these dancers, dressed "à la nymphale," were expert at the art of self-display.[14] For female dancers, paid to reveal their limbs while going through their steps, the ballet was the arena in which their alleged exhibitionism was sanctioned, even required.

Degas' many drawings constitute a repository of possible solutions to the positioning of the dancer's feet. On a sheet of studies from the 1880s, for example, feet and arms echo rhythmically across the surface in a pictorial dismemberment of the figure that is partially reassembled on the same page (fig. 11). In places, outstretched arms and extended legs seem to fuse, creating strange figural hybrids, joined by overdetermined vivid orange patches which mark and mask points of intersection. Here, the obsessive recording of body parts reads as hallucination or fantasy, a compulsive repetition and repositioning undermining the rationalist discourse of realist observation. Registered, too, is the process of both drawing and dancing as perpetual rehearsal. Just as the ballet is made up of routines and repetitions, rhythmically orchestrated across the stage, its preparation a matter of false starts, hesitant replays, and rigorous rehearsal, so the act of drawing for Degas comprised a series of statements and erasures, assertions and corrections, the effect of which is to register the labor of art as well as the obsessive fracturing of the bodies that formed its basis.

In an early work like *Dance Studio at the Opera on the Rue Le Peletier* (1872), memory and observation come together on the canvas to create the image of an encounter in the present (see fig. 1). Casting her shadow on the floor beneath her, the dancer at the front left-hand corner of the picture goes through her routines, transformed in the oil painting from the isolated life model in the studio, captured on paper in an earlier drawing, to a social participant in a group activity situated in the recognizable context of the rehearsal room at the rue Le Peletier. The specific setting is carefully adumbrated with moldings, niches, and openings, the mirrors clearly delineated, while the dancers for the most part hug the walls as they either practice at the bar, do their exercises, stretch, or watch from the margins. Behind the half-opened door at the left, a fragment of a dancer's tutu and leg creates an echo of the figure in front by duplicating her essential shape and attitude. The repetition of the dancer's body, headless and faceless behind the door, points to her position as a member of the corps, the group of identically clad and

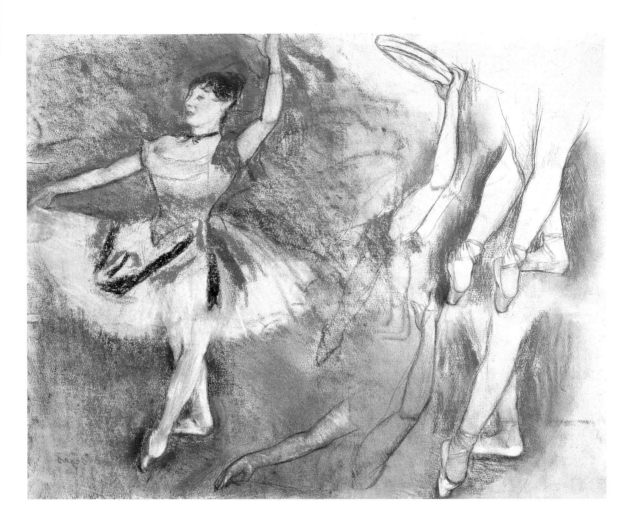

11 Edgar Degas, *Dancer with Tambourine, or Spanish Dancer*, ca. 1882
Pastel with black pen, 46 × 58 cm
Schormans, Collection fonds Orsay, Louvre, Paris. Photo credit: Réunion
des Musées Nationaux / Art Resource, New York; reference ART149780

choreographed figures who form the chorus and for whom synchronization and timing is everything.

Degas the historian, to use Paul Mantz's description, situates his figures in the credible context of the classroom. Orchestrated around the figures of the teacher and musician, the ballerinas take up their prescribed positions, waiting for the sign that will animate their bodies and unfreeze the moment. But painting, unlike dance, stands still, its temporalities always fictive rather than real, its resonances spatial rather than durational. Historical time is represented in details of location and setting, but time as duration and rupture, repetition and reversal, is registered less within individual images themselves than in the serial production of figures and forms that Degas' practice entailed. Repeatedly, Degas would make use of the same figures and poses, recontextualizing these in different settings or altering them slightly in color, costume, and placement. In 1873, for example, the two figures stretching at the bar at the back left-hand section of *Dance Studio at the Opera on the Rue Le Peletier* would be repeated in a small oil study, *Dancers Practicing at the Barre*, that isolated their figures on an indeterminate green ground (fig. 12). A figure study, this small-scale work focused on the bodies of the ballerinas, adumbrating them in line and tone without stipulating setting or scene. Such details would be left for "finished" oil paintings designed for public exhibition. In 1900, Degas was still returning to the poses of this early pair in his dance compositions, quoting and recycling earlier figures and groups in vague and unspecific locations (fig. 13). But by this time, the project of "Degas the historian" had been abandoned. None of the observational detail of *Dance Studio at the Opera on the Rue Le Peletier* is present in the late work. Gone is the specificity of setting and surroundings. The props and accessories, like the fan and cloth on the empty chair that functioned in the earlier work as testimonials to the here and now, have disappeared. Now the dancers take up their positions in a field of color, their identities merging with that of the surrounding space. Simply divided tonally and by a faintly adumbrated diagonal line, the surface of Degas' late work reads as flat and pictorial, while the bodies of the dancers come into being as so many patches of color, smudged, erased, and pulled into shape. Bodies bleed out of boundaries, hues and contours collide, destroying conventional distinctions between color and line, body and space, inside and outside.

Pictorially rich, but devoid of detail, these late pictures throw into question the status of dance as a subject for painting. While the image of the dancer retains residual connotative power, it has been evacuated of specific

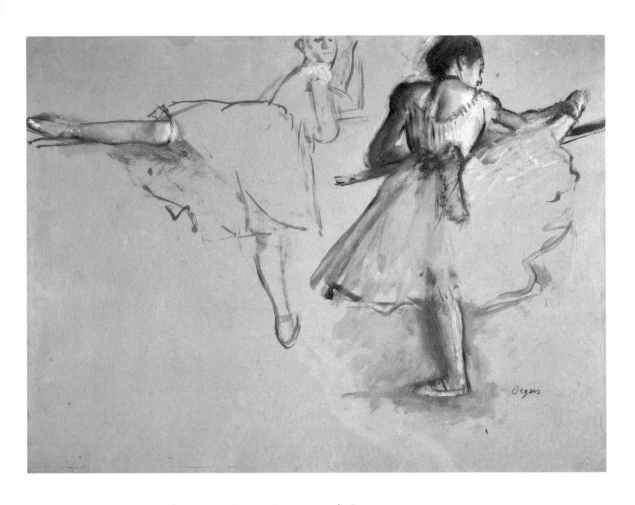

12 Edgar Degas, *Dancers Practicing at the Barre,* ca. 1876
Oil paint thinned with turpentine on green paper, 47.9 × 62.5 cm
British Museum, London; PD. 1968-2-10-25. Photo credit: HIP / Art Resource,
New York; reference ART179434

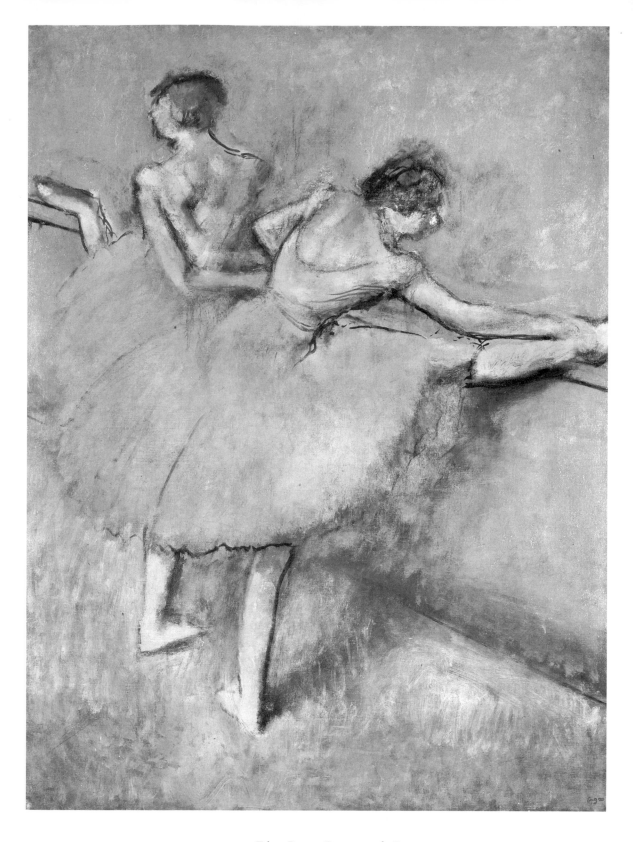

13 Edgar Degas, *Dancers at the Barre*, ca. 1900
Oil on canvas, 130.2 × 97.8 cm
Phillips Collection, Washington, D.C. Photo credit: Scala / Art Resource, New York;
reference ART15454

historical or social references, and seems to operate more as a vehicle for the exploration of pictorial possibilities than as the representation of a socially specific figure. Distilled from earlier images, a matter of quotation and adaptation, it seems to refer to the self-enclosed space of art rather than the heated exchange of life.

During the three decades that separate these works, Degas had grappled with the competing demands of picture-making and those of depiction or description. Never seduced into believing that art was other than a material practice, he had always relied on manipulation and fabrication in the construction of his pictures. But his commitment to contemporary life and Nature (as the Impressionists liked to call it) had remained strong for decades. Now, in the context of the newly emergent aesthetic theories of Symbolism, the aging and increasingly blind artist lessened his hold on the real, coaxed and advised by his friend, the poet Stephane Mallarmé. Mallarmé was committed to a belief in the concrete and formal languages of Art as the foundation for an alternative conception of meaning rather than as a vehicle for the expression of ideas and attitudes. For Mallarmé, poetic language, unlike the instrumental languages of daily living, did not need to convey information or describe experience. Rather, its power was in its capacity to evoke mood and atmosphere, creating its own rich sonic correspondences through suggestive juxtaposition and evocative conjunctions, which deferred neither to logical sense nor to the laws of grammar.

When asked about the female dancer by the young poet Paul Valéry, Mallarmé had dismissed the importance of the identity of the figure portrayed, asserting: "The female dancer is not a woman who dances, because she is not a woman and she does not dance."[15] The truth of Mallarmé's statement is blindingly obvious. We are in the realm of representation here, not that of experience.[16] There is no actual dancer present. We are dealing with symbolization, not reality. When the frustrated Degas, who was dabbling in poetry, had asked Mallarmé why, when he was so full of ideas, he was having so much difficulty with the sonnet he was trying to write, Mallarmé had retorted: "But Degas, it is not with ideas that one makes poetry. It is with words."[17]

This Degas had always known. He had always laid bare the means of his own recording of nature; the lines, shapes, colors, and tones that constituted the language of art. And yet, he could not make poetry or pictures out of nothing. It was his physical engagement with the visible world that, invested with powerful sensory and erotic associations, fueled his imagination, and that had, from the start, unleashed his productive energies. For this reason,

drawing from life remained crucial to him throughout his career, and his sessions in front of the model provided a store of new images to be manipulated and reworked in pastel and paint. Encountered in the present, the body of the model could be endlessly recycled in a fabricated pictorial world made of line, color, and shape. But even though the temporal registers of the late works became more abstracted and generalized, the social encounter of artist and model in the space of the studio, as well as the capacity of the female figure to function as the cipher on which they were premised, remained as time-bound and historically specific as the detailed interior of the rue Le Peletier itself.

Despite Mallarmé's iconoclastic and prescient insight, at the core of Degas' dance practice *was* the body of the female dancer, an erotically charged, socially constructed, gendered body, manufactured in the classrooms and corridors of Europe. This is nowhere more concretely demonstrated than in his series of nude dancers from the 1890s and early 1900s, drawn while he was engaged in composing his increasingly abstracted, generalized pastel and oil dance scenes. In these drawings, Degas stripped the dancer of her outer garments, repeatedly and compulsively capturing on paper the characteristic gestures and positions of her naked body (fig. 14). For Degas, to draw the body was to know the body, and his inquiring line searched the page for the correct outline or accent to describe the curve of a torso or the angle of a limb. Leaving the traces of his investigation visible on the page, as he had done from the early years, the drawings are made up of accretions of exploratory marks, registering the trail of the artist's hand as he struggled to master his responses to the woman's body in front of him. But, as we have seen, the marks that make up the drawing, though motivated by a response to the model, far exceed the imperatives of description and depiction. In *Three Nude Dancers* (1903), for example, three figures are captured in charcoal on tracing paper, but it was very unlikely that Degas had three models posing simultaneously when executing this drawing (fig. 15). It is more probable that a single model took up three different positions in the course of a sitting. Three successive poses become synchronized into an encounter which only exists on the sheet of paper. It does not precede the drawing, nor exist outside of it. The relationship between the nudes, therefore, figured as smeared charcoal which follows the curve of a back or heavy repetitive marks which suggest a shadow or a dark space, makes manifest the fabricated dimension of drawing, which holds in balance the processes of description and invention such that it becomes impossible to tell where one ends and the other begins. Marks exceed their descriptive remit, asserting the pressure of the hand of the witness, "his" signatory squiggles and scratchings, erasures and

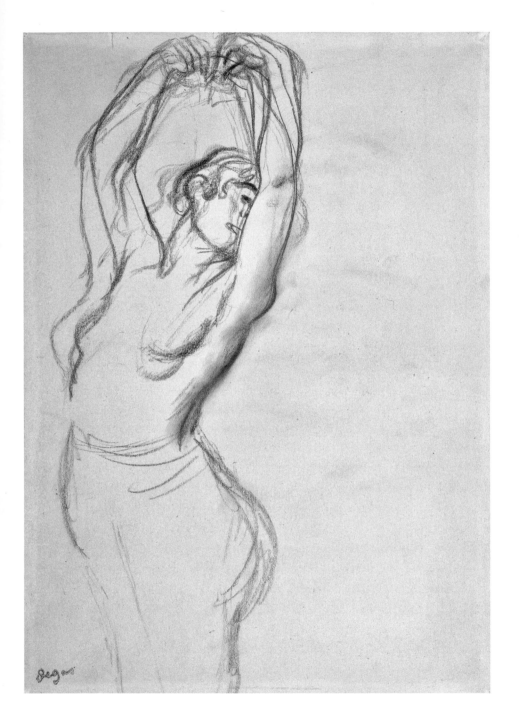

14 Edgar Degas, *Nude Dancer with Arms Raised*, ca. 1890
Black chalk on woven paper, 32.7 × 24 cm
Statens Museum for Kunst, Copenhagen; acc. no. KKS8524

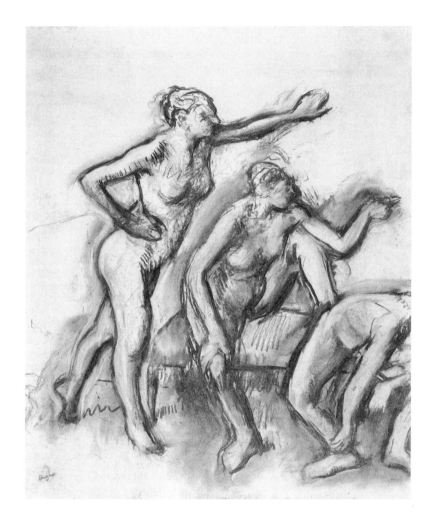

15 Edgar Degas, *Three Nude Dancers*, ca. 1903
Charcoal on paper, 77.2 × 63.2 cm
Arkansas Art Center Foundation Collection; purchase of the Fred W. Allsopp
Memorial Acquisition Fund; acc. no. 1983.010.002

smudging, animating empty space and solid surface alike with self-generating gestures.[18]

Degas continued the academic practice of working out his figure studies nude, then clothing and adjusting them in colored oils and pastels. Tracing the contours of the dancers repeatedly onto other surfaces, he would "dress them up" in their costumes to perform their roles as decorative ciphers. The three "models" in the charcoal study *Three Nude Dancers*, for example, appear in green tutus in front of a patterned backdrop in a pastel on tracing paper of the same period. In *Dancers* (fig. 16), the splayed legs and vulgar gestures evident in the drawing are covered over, costumed and occluded by flared skirts and semi-transparent gauze, but the raw physicality of the turned-out feet, muscular calves, and blunt physiognomies remains, despite the indeterminacy of setting and the paucity of contextual detail. The dancers merge with the surrounding space, their tutus flaring up to meet the encrusted color and texture of the backdrop, making bodies and surface fuse in a rich decorative design in which femininity is both the property of the models themselves and is dispersed and displaced so that it becomes a property of the image.

A similar transformation is evident in a number of charcoal drawings of a dancer, doubled over towards her foot, her hands mimicking the gesture of tying a shoelace (fig. 17). In studies like these, Degas grappled with foreshortening the thigh and understanding the space between the legs even though these areas would be concealed by costume in subsequent paintings and pastels. Duplicated and swivelled round in a frieze of four dancers painted around 1895, the same figure is placed, repeatedly, in an indeterminate setting, with no indication of floor and wall, let alone the concretizing details of watering can, musical instrument, or discarded garment so often included in earlier compositions (fig. 18). Instead, the composition reads as a series of echoing shapes and colors overwriting the drawn-in bodies of the rotated figure.

Mallarmé was right: neither woman nor dancer is present here. If poetry is made out of words, then pictures are made out of lines and colors, shapes and shades, no matter what they represent. *Frieze of Dancers* recycles the same figure from four different angles, repeating the curve of the back, the sweep of the transparent skirt, the encircling gesture of the arms, like so many rhythmic accents on an extended scroll. Overwriting the crouching figures is a repeated patch of green which seems to hover in front of the bodies and on the ground beneath their skirts in an inexplicable act of replication that effaces rather than describes the figures. Standing for the opaque stain of representation, this series of patches points to the material presence of pigment

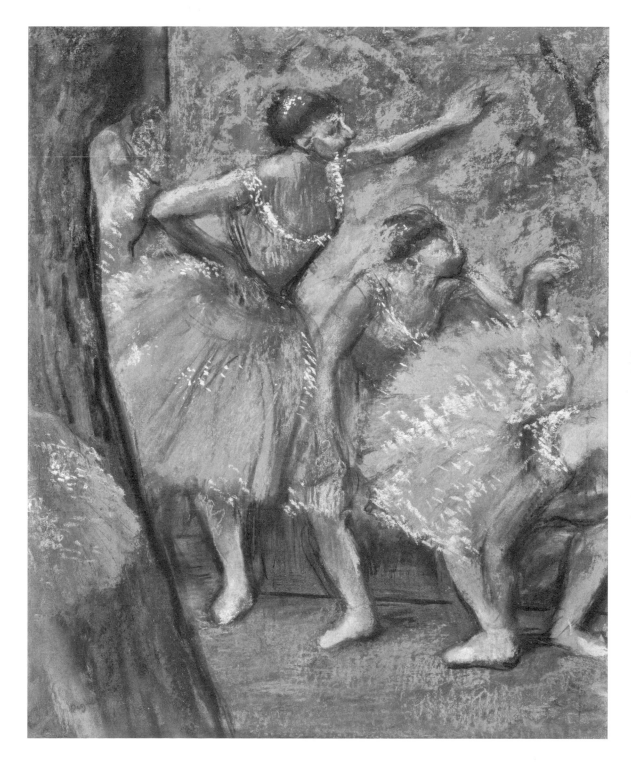

16 Edgar Degas, *Dancers*, ca. 1897–1901
Pastel on paper, 73.5 × 61 cm
Private collection, Switzerland. Photo credit: Erich Lessing / Art Resource,
New York; reference ART128993

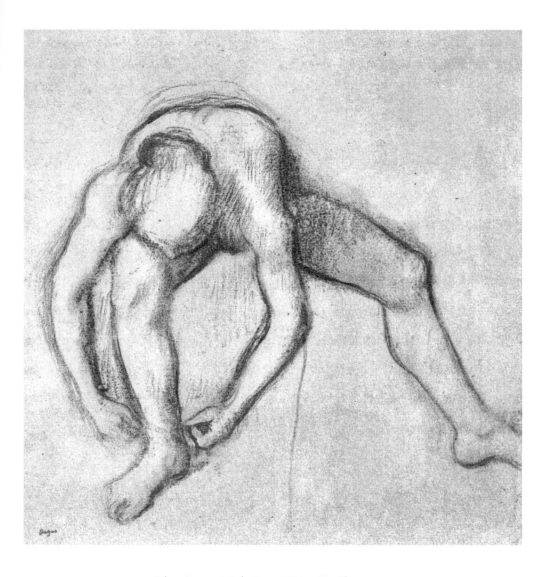

17 Edgar Degas, *Nude Dancer Tying Her Shoe*, ca. 1893–98
Charcoal on bull paper, 56.7 × 59.7 cm
Collection of Mr. and Mrs. Nico Delaive, Amsterdam

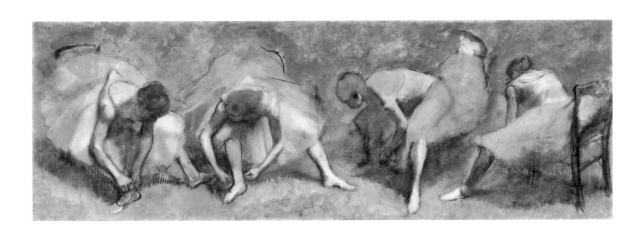

18 Edgar Degas, *Frieze of Dancers*, ca. 1895
Oil on canvas, 70 × 200.5 cm
The Cleveland Museum of Art; bequest of Leonard C. Hanna Jr.; acc. no. 1946.83

and paint and the failure of figuration to describe fully the world it conjures. But, at the same time, one cannot entirely forget the specificity of the partially camouflaged figures that are pictured here. There is none of the prettiness or coy coquettishness of Renoir's pubescent dancer of thirty years earlier. Nor do we witness the idealized, standard depiction of the romantic ballerina. These bowed and spread-legged workers, for all the vagueness of their setting and situation, register their social and sexual specificity in the vulgar poses, mundane gestures, and stooped postures that they assume. Beneath their diaphanous skirts, the lines of their leotards remain visible, as do the curve of their hips and the shape of their tilted buttocks. In addition, the repetition of action and pose asserts the banal repetitiveness of practice and performance to which they were subject, and for which their well-trained, muscular bodies were adapted. Built from an intense encounter in the studio, in which the sexuality of the model had been explicitly depicted and described by the searching hand of the artist, the painting belongs not only to the world of the aesthetic but also to the world of the erotic, not only to an abstracted and disembodied ideal but also to a regime of representation dependent in this context on the exchange of women as models, as dancers, and as vectors for the transformation of body into spirit, symbol, or anything else. If history was made manifest in the concrete details of setting and situation in the early works, then it is no less present when such "information" is occluded or suppressed in the late works. For the very abstraction of the female dancer that Mallarmé advocated was, itself, the product of history, predicated on ideals of femininity and constructions of sexuality that were time-bound and culturally specific. If history shapes the body, it must continue to do so even when the legible signs of its historicity have been apparently eclipsed.

PORTRAITURE & THE NEW WOMAN

TWO WOMEN ARTISTS ARE STAGED IN A MOMENT OF SUSPENDED labor. Their occupation, as much as their appearance, defines them. The one, palette in one hand, laden brushes in the other, is dressed plainly and comfortably in her working attire (fig. 19). Her belted apron and dark daywear constitute a sensible and appropriate costume for working at the easel, while her unadorned head and plain hairgrip offer no distraction from the intensity of her gaze and the intelligence of her expression. Framed by a plain brown drape, which provides a sober backdrop to the alert figure, the erect body seems perched on its hard wooden chair, ready to rise or turn back to the easel and continue with its work. This is a self-portrait by the Polish painter Anna Bilinska-Bohdanowiczowa, who lived in Paris, and in it, the artist seems to assert her professional identity and character, her individuality.

The portrait *Rosa Bonheur*, painted some ten years later by Bonheur's companion, Anna Elizabeth Klumpke, is equally forthright in its assertion of professional and personal particularity (fig. 20). The renowned animal

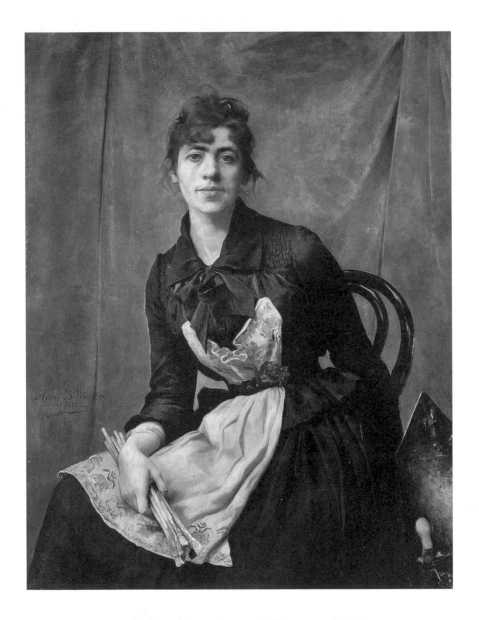

19 Anna Bilinska-Bohdanowiczowa, *Self-Portrait with a Palette*, 1887
Oil on canvas, 117 × 90 cm
National Museum, Krakow

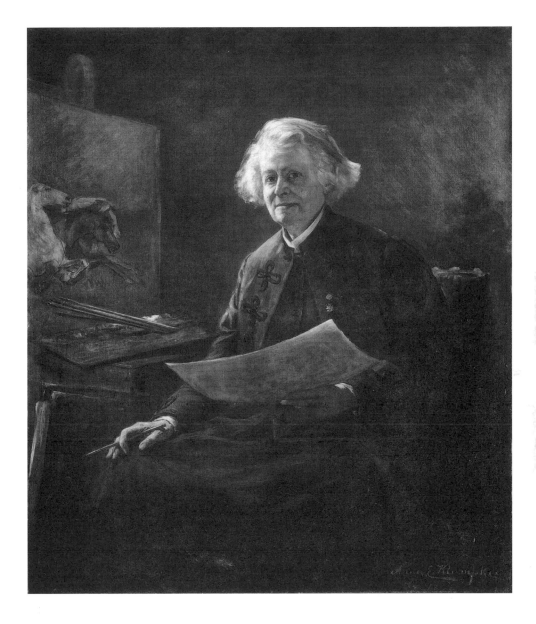

20 Anna Elizabeth Klumpke, *Rosa Bonheur*, 1898
Oil on canvas, 160.3 × 98.1 cm
Metropolitan Museum of Art, New York; gift of the artist in memory of
Rosa Bonheur, 1922; acc. no. 22.222

painter is posed in front of a characteristic painting depicting rearing horses. She holds a preparatory drawing, pencil poised between her fingers, laden palette and balanced brushes propped beside her. Dressed in formal attire, replete with *legion d'honneur* pinned to her militaristic jacket—she was the first woman in France to be accorded such an honor—the sobriety of Bonheur's costume is relieved only by the light that falls on her competent hands and intelligent countenance. Hair cut short and plainly combed, face devoid of makeup or any sort of adornment, Bonheur sits manfully on her chair, her legs comfortably apart, her gaze alert and engaging.

Both these portraits assert the specialized expertise of their female protagonists. They are tonal paintings, with the figures framed by dark expanses of paintwork, and each shows the use of careful and controlled lighting to highlight particular props and body parts. Hands, faces, and signs of professional identity are illuminated and carefully delineated. Alert and unidealized faces with furrowed brows, evidence of aging and characteristic expressions, confer distinction and dignity on the sitters. Sobriety, seriousness of purpose, and high-minded endeavor are the values that the portrayals emit. They convey character, psychological depth, individuality, and professional prowess.

None of these qualities is the conventional remit of female portraiture.[1] It was portraits of men, not women, that had traditionally shown social status, professional identity, and personal character. Male portraiture was invariably required to provide a "psychological document" of an individual and to proffer a subject for analysis and moral examination. In the case of an unknown sitter, what was known as his "race" and the dominant beliefs of his epoch would be judiciously inscribed on his exterior; in that of a famous man, his signatory thoughts and deeds needed to be legible on his person, etched onto his physiognomy and expressed in the network of lines and traits that were visible on his countenance. Setting and context were designed to inform the viewer of the sitter's position and role in life. Age, wisdom, intensity of engagement, and sobriety of endeavor were all virtues in a man, and portraiture was required to depict them.

Edouard Manet's *Portrait of Emile Zola* (1868), for example, shows the writer surrounded by his professional accoutrements (fig. 21). Drawing on earlier prototypes of the *homme de lettres*, Zola is shown in his study, replete with books, pamphlets, writing paraphernalia, and pictures—a veritable shrine to print and paint. Containing specific references to the writer's relationship to the artist, the portrait also functions as a manifesto of their mutual commitment to specific aesthetic ideals: the reclining nude in the small reproduction of Manet's *Olympia* turns to look at the critic who had so

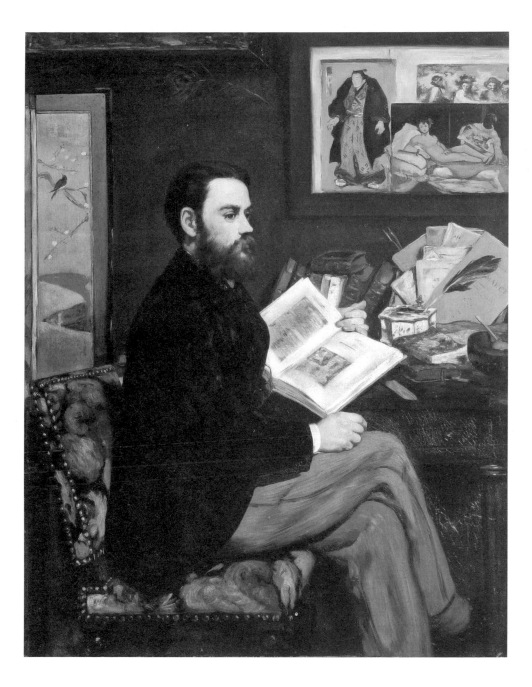

21 Edouard Manet, *Portrait of Emile Zola*, 1868
Oil on canvas, 146 × 114 cm
Musée d'Orsay, Paris; gift of Mme Emile Zola, 1918, acc. no. RF2205.
Photo credit: Erich Lessing / Art Resource, New York; reference ART26744

vigorously defended it in print, while the pamphlet in which he had done so is prominently displayed on the table. A taste for Spanish naturalism, Japanese woodblock prints, and Chinese porcelain, as well as specific literary interests, are all indicated in a portrayal that serves as an homage to the sitter while also representing a dialogic encounter between two modern male professionals.[2]

Viewing a portrait of a man involved laborious looking. It required an active, cerebral encounter with the image of the person portrayed, as well as the deciphering of clues and signs, carefully tracked by the portraitist, that revealed the sitter's class, social status, and personal identity. The pleasures to be had from such looking were, definitively, intellectual. But portraits of women were traditionally required to serve a different purpose. Indeed, a cerebral encounter was, allegedly, the furthest thing from the viewer's mind when viewing the portrait of a woman. A spur to the imagination, to fantasy and reverie, portraits of women needed to titillate and entice, not edify or inform. Traditionally, the forms and shapes of female portraits, their shadowy recesses and opulent surface textures, their juxtapositions of flesh and fabric, folds and drapes, had been organized to provide an imaginative space into which male viewers could project their own desires. Mysterious mirrored interiors or vague unidentifiable landscapes were designed to provide appropriate sensual and suggestive settings for staging the female sitter. Nineteenth-century portraits of women, as epitomized in works by Jean-Auguste-Dominique Ingres, were habitually required to represent an image of sensual delight and surface pleasure, and to provide a screen onto which the passions of successive viewers could accumulate and resonate (fig. 22).

Such, at least, was the elegantly expressed and typical view of the erstwhile symbolist critic Camille Mauclair, writing in *La Nouvelle revue* in 1899.[3] In an ambitious article entitled "La femme devant les peintres modernes," Mauclair delivered an account of the historical gendering of portraiture and the profoundly distinct conventions of representation and modes of viewing that portraits of men and women had traditionally required. In female portraiture, alleged Mauclair, it was not the particularity of the face or the identity of the sitter that characterized the successful picture, but rather the capacity of the woman depicted to provoke desire. Viewing a female portrait had always been, in his view, an entirely different experience from that of viewing a male portrait. Whereas a portrait of a man was a psychological document through which the motivations and actions of the sitter were conveyed, his place in society stipulated, and his relationship to the broader culture communicated, a portrait of a woman was less a portrayal of an individual than a screen for the projected sensibilities and passions of the spectator. It was his gaze that

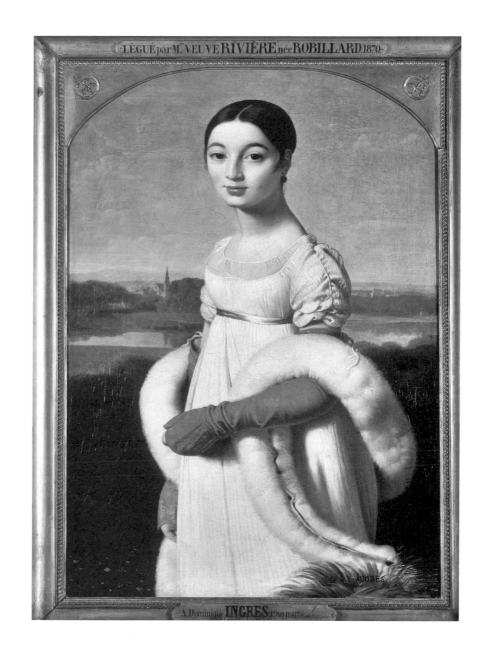

22　Jean-Auguste-Dominique Ingres, *Mademoiselle Caroline Rivière*, 1806
Oil on canvas, 99.5 × 64.5 cm
Musée du Louvre, Paris. Photo credit: Scala / Art Resource,
New York; reference ART15914

gave ultimate form to the woman portrayed, complementing the first order projections of the painter. The painter's duty was to express a woman's traits and to define her physical appearance, but it was the spectator who remade that being into the image of his own fantasy and desire. Ideally, the portrait of a woman stimulated a response exactly opposite that prompted by the portrait of a man. The last thing it was required to do was confront the spectator with a powerful, autonomous subject who encountered him as an equal, or even as a superior. Woman, for Mauclair, functioned as the physical incarnation of masculine desire. She was nothing in herself. Beyond the projected fantasies of her admirers, there lay a vacuum, a void. Woman was surface, and surface alone. Whereas the portrait of a man could be compared to a map that needed to be deciphered, that of a woman represented an unknown territory where there were neither traces nor demarcated routes and where each explorer would find his own path. Woman was ultimately unknowable because she was purely physical. A hollowness, a vast and cavernous emptiness, was all that lay behind her carnal beauty.

Exemplary prototypes of female and male portraiture and the concomitant viewing positions they demanded were provided, for Mauclair, by Leonardo's *Mona Lisa* and Holbein's *Portrait of Henry VIII* (figs. 23, 24). Embodiments of a sexually differentiated world, these icons of femininity and masculinity elicited distinct and highly specific responses in the viewer. Whereas the male portrait subject was an interlocutor with an assertive presence, the *Mona Lisa* functioned, quintessentially, as a stimulus to fantasy. Her smile, alleged Mauclair, had led many a man to muse on the smile of his own beloved, inducing an exquisite reverie in the mind of the beholder. An extension of the landscape, she does not hinder his imaginative possession of the ethereal space that she occupies. Rather she entices him into it, promising a mysterious and unfathomable path to self-discovery.

A portrait of a woman, declared Mauclair, is always a decorative work, a tableau first, made up of lines and colors, folds and crevices, and a portrait second, akin to a landscape in which a woman's body functioned as the generating motif and captive core of the painterly ensemble. Constituted as pure form, the female sitter, in a state between dress and undress, being and becoming, ideally allows the viewer to peruse the pictorial surface without disrupting its integrity. Her body forms part of the landscape, its shadowy recesses, hollows, and crevices inviting the eye to probe and traverse it in a journey of discovery analogous to the one taken along the winding and mysterious paths that constitute the figure's background. Not unlike Mallarmé's female dancer, Mauclair's female sitter functions as a vector for artistic

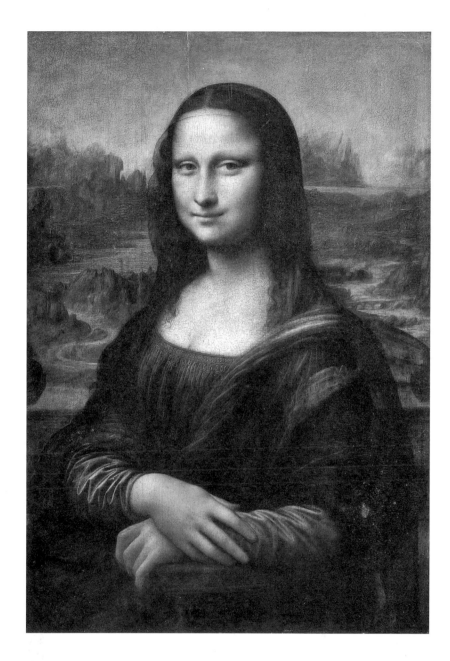

23 Leonardo da Vinci, *Mona Lisa*, 1503–06
Oil on wood, 77 × 53 cm
Musée du Louvre, Paris; inv. 779. Photo credit: Erich Lessing / Art Resource,
New York; reference ART36777

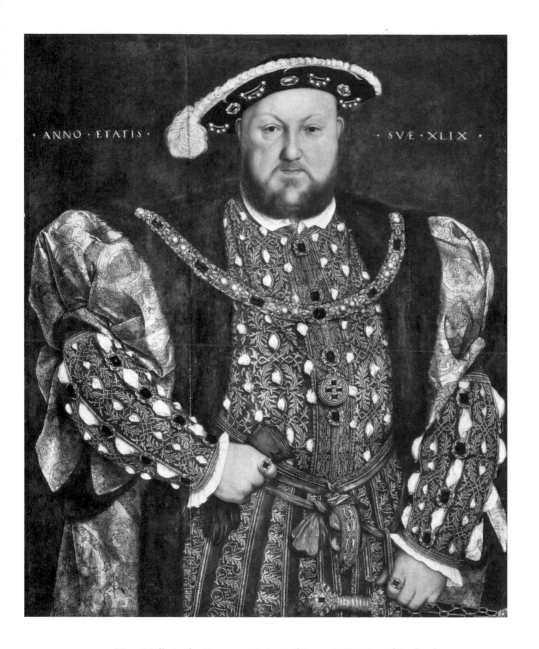

· ANNO · ETATIS · SVÆ · XLIX ·

24 Hans Holbein the Younger, *Portrait of Henry VIII, King of England*, 1540
Oil on canvas, 88.5 × 74.5 cm
Galleria Nazionale d'Art Antica, Rome. Photo credit: Scala / Art Resource,
New York; reference ART36882

expression, a vehicle for relations of pictorial form rather than a resistant subject asserting its own historical specificity.

By contrast, Mauclair's male counterpart, epitomized by the regal image of Henry VIII, shows a flattened, full frontal presentation of a sitter who occupies nearly the entire picture space. His body is pushed commandingly up to the front of the picture plane, as if to confront his subjects; the background is flattened and shallow, leaving no room for the eye or imagination to wander, instead providing a surface on which the date of the King's reign is emblazoned. Facial features are carefully delineated, the regard magisterial and purposeful, the effect imposing, even intimidating. Appurtenances of office, directed gaze, elaborate costume, and imposing stance all ascribe ultimate power to the model, leaving the viewer gazed upon, rather than capable of the imaginative possession engendered by the *Mona Lisa*. Whereas the painter, wrote Mauclair, must never express what a woman thinks, but rather what he thinks of her, in a portrait of a man he needed to render the thoughts, the consciousness of his sitter, as well as his own response to them, while still managing to capture a physical likeness.[4]

For Mauclair, a male effigy required the precise inscription of traits, the faithful rendition of features and distinctive characteristics of status and position, while the image of a woman demanded an overall harmonious arrangement of pictorial values, of shadows and lights and atmospheric effects. This was sufficient for the essence of Woman to be conveyed. Masculine individuality disrupted the appreciation of a portrait as a picture, but femininity offered no such obstacle. Portraits of women were pictures first, the imaginative projections of their viewers, and portraits of individuals second.

Although Holbein's kingly image offers an extreme rendering of monarchic power, countless late nineteenth-century portraits of men conformed to Mauclair's model for masculine portraiture, investing masculinity itself with a masterful self-possession (fig. 25). For Mauclair, the only features worthy of note in portraits of men were the distinctive heads and the characteristic hands emerging from what he described as the "black anonymity of (men's) costumes." Men's clothing, he declared, was of little significance. Even in earlier periods, when sumptuous clothing, lush fabrics, jewelled accessories, and fine marks of sartorial distinction lent dignity and specificity to individual figures, it was, according to Mauclair, always the face of a man that was the most important aspect of his person and with which the viewer immediately engaged.

The portrait of a woman, on the other hand, could not be judged by her face. Indeed, too specific a physiognomy could hinder its appreciation. Fash-

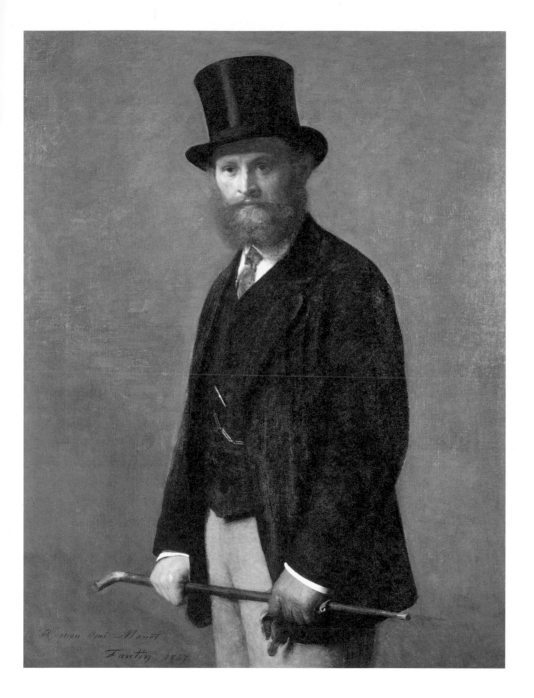

25 Henri Fantin-Latour, *Portrait of Edouard Manet*, 1867
Oil on canvas, 117.5 × 90 cm
Art Institute of Chicago. Photo credit: Erich Lessing / Art Resource,
New York; reference ART214075

ion and costume characterized and comprised the feminine. Woman was a decorative surface, an empty shell which needed to be cloaked and adorned in the style of the moment. Like a blank canvas, she was nothing until covered by the projections of those who created her. Offering no resistance to the pure pictorial qualities of painting, she was subsumed into its decorative remit. The overall effect of a painting, its entire surface, required unravelling, if the sitter's seductive charm was to be revealed. Indeed, for Mauclair, a successful portrait of a woman always remained a mystery. Appreciating it took time.

The character of a man could be found in his face and figure. But a female figure, her body occluded by fabric, swathed in silks, surrounded by drapes, trimmings, lace, and bows, was suggested but never fully displayed, and had to be discovered in the recesses of the paintwork, through imaginative reconstruction and the filling in of gaps. Ingres' portraits of women provided the prototype for a femininity dispersed throughout the surface of the picture. In the folds of fabric that surrounded her, in the pleats and tucks and protrusions of her costume, her mystery resided, and it was up to the slow, caressing gaze of the viewer to reveal it.

It was in late nineteenth-century society portraiture that the pictorial construction of femininity outlined by Mauclair remained clearly visible. The walls of the exclusive salons at Georges Petit and the private drawing rooms of the wealthy displayed countless images of bejewelled women dressed in haute couture gowns in indeterminate settings (fig. 26). Moody expressions, vague features, subtle skin tones, and silken surfaces were the order of the day in such tributes to female beauty. By contrast, Ingres' famous portrait of the publisher Louis-François Bertin exemplifies the traits of nineteenth-century male portraiture (fig. 27). It demonstrates flattened, full frontal, masculine sobriety and carefully delineated facial features, as opposed to the dreamy indistinct setting and undulating soft focus corporeality epitomized by the popular portraits of women by painters such as Alexandre Cabanel.

Such differentiated iconic models of masculinity and femininity served nineteenth-century social codes well, and it is not surprising that these conventions, if not universal, were nevertheless widely employed by fashionable portraitists at the end of a century characterized by the hypostatization of gender roles. But they did not, of course, offer exclusive portrait prototypes, and even the socially and aesthetically conservative Mauclair was aware of the way in which the schema that he described had been challenged by modernity and its concomitant new aesthetic ideologies, Realism and Naturalism. With their remit of fidelity to nature and truth to external appearances, their faith in positivism and the new scientific discoveries of the emergent disci-

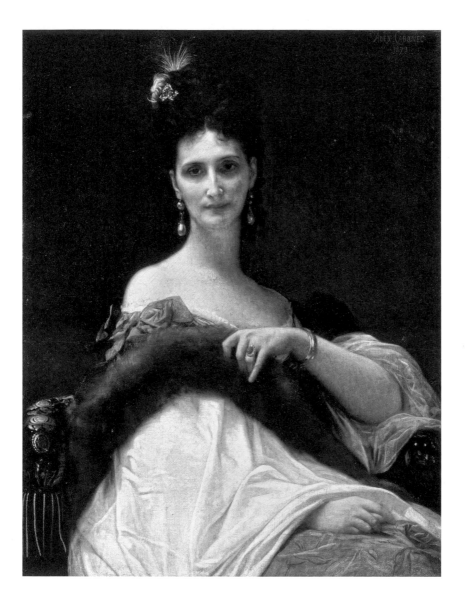

26 Alexandre Cabanel, *Portrait of Countess de Keller*, 1873
Oil on canvas, 99.2 × 76.0 cm
Musée d'Orsay, Paris. Photo credit: Réunion des Musées Nationaux / Art Resource,
New York; reference ART147331

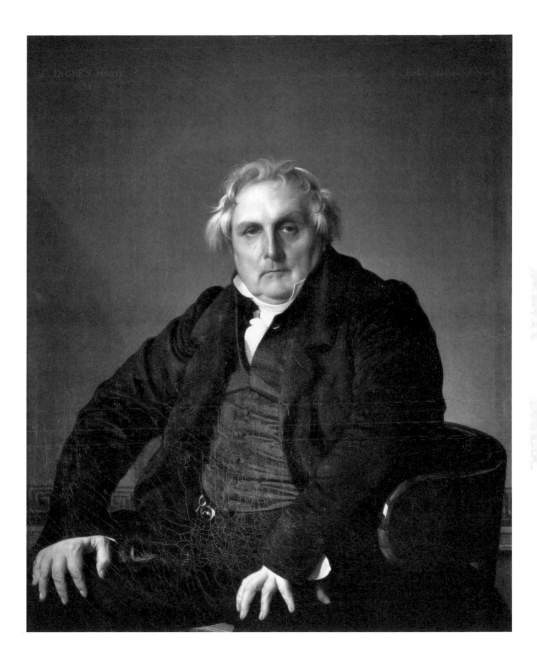

27 Jean-Auguste-Dominique Ingres, *Louis-François Bertin*, 1832
Oil on canvas, 116 × 95 cm
Musée du Louvre, Paris. Photo credit: Erich Lessing / Art Resource, New York

plines of psychology, ethnology and sociology, realism and naturalism had, at least since the 1860s, provided the framework for a transformation of female portraiture, wherein the individuality of the sitter needed to be taken into account. Such changes in modes of representation were to coincide with emergent new definitions of femininity that would alter the traditional French conception of female portraiture.

By the time Bilinska-Bohdanowiczowa and Klumpke came to produce their highly individuated renditions of female painters, the woman artist had become a recognizable modern social type and the traditional idealization of the female effigy had been dented by social change and the emergence of realism. Edouard Manet's portrait of the painter Eva Gonzalès, for example, had been roundly condemned for over-particularizing the face and body of its female protagonist when it was exhibited at the Salon in 1870 (fig. 28). Manet's figure's alleged exaggerated features, hooked nose, pasty complexion, and awkward arms had, the critics agreed, amounted to an insult to his female sitter and an assault on her femininity. Realism had demanded a more penetrating vision than either etiquette or chivalry allowed, and for all the portrait's *dix-huitième* grandeur and stagey artifice, both artist and sitter became the critical casualties of Manet's too particularizing gaze.[5] Yet, by 1899, Mauclair was happy to reproduce the notorious portrait in his article on female portraiture and to use it as an example of Manet's profound originality, describing him as the "most expressive physiognomist of women of the Second Empire" and "amongst the most beautiful painters of the modern woman."[6] In his account, Gonzalès' singularity was expressive of the social and psychological identity that Manet conferred upon the women of his time, making him a faithful chronicler of changing social mores and attitudes. Where Manet's awkward negotiation of traditional codes for portraying the feminine (via the exigencies of realism and the demands of new notions of female agency) had produced an image that was largely illegible in 1870, by 1899 it could be accommodated under the aegis of a now tamed naturalism and a recognizable social type. No longer threatening, Eva Gonzalès signified as a modern woman and Manet as her prescient observer.

Edgar Degas' perspicacious eye and realist vision was also praised by Mauclair, who described him as the admirable "historiographer of modern feminine musculature."[7] But it was as a painter of bathers and dancers, rather than a portraitist of women, that Mauclair admired him, seeing him as following in the tradition of the printmaker Constantin Guys, the "great psychologist of the feminine creature." Deploying a language of symptoms and signs drawn from current medical and psychological accounts of female subjec-

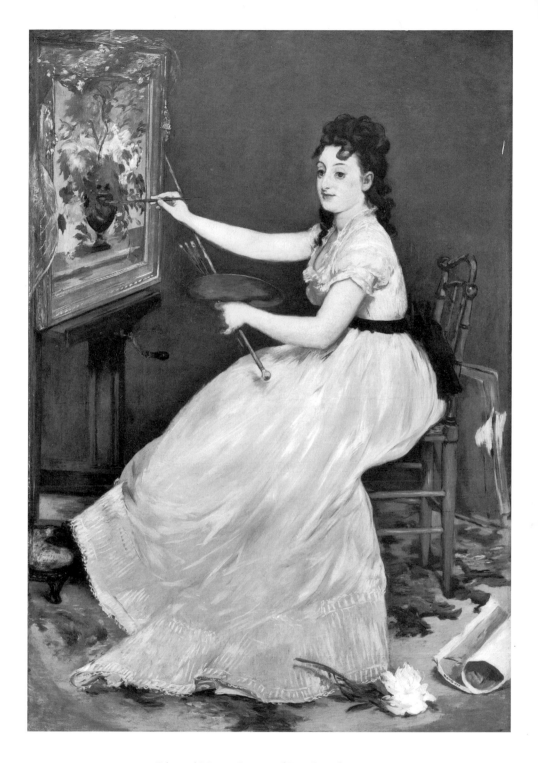

28 Edouard Manet, *Portrait of Eva Gonzalès*, 1870
Oil on canvas, 191.1 × 133.4 cm
The National Gallery, London

tivity, Mauclair characterized Degas as having best captured the "leanness," the "nervousness," the "ticks," curious gestures, expressions, and habits, "the ugly intelligence," in all its varieties, that modern femininity could assume. In a catalogue of character traits that sounds like the perfect job description for the hysteric, Mauclair reveals the fin de siècle construction of femininity that functioned for him and his contemporaries as an account of the nature of modern Woman. Degas the realist, according to Mauclair, denuded Woman of the aureole of masculine desire which had hitherto surrounded her, and truthfully revealed her as nature had made her.

Degas' "psychological study" and discreetly caricatural approach, along with Manet's "realism," were offset for Mauclair by their contemporaries, Paul-Albert Besnard and Pierre-Auguste Renoir, who continued, throughout the fin de siècle, to give form to a traditional fantasy of femininity (fig. 29). Yet, despite the continued depiction of woman as the embodiment of grace and languor, the incarnation of desire or a pensive, meditative effigy, Mauclair also detected, in a number of powerful images produced toward the end of the century, new and emergent qualities—female individuality and the profound self-consciousness associated with an assertive subjectivity. These qualities were most obviously displayed in portraits in which generic forms of behavior, gesture, and deportment were offset by markers of individual distinction and particularity. Many women, he alleged, were no longer indifferent creatures content to reflect the desires and thoughts of the men of their time, but were instead interested in asserting an identity of their own. They had liberated themselves from the barriers of tradition, mixed in society, shared the cares and responsibilities of modern men, assumed some of their customs and habits, and acquired an equivalent personality. What was more, their external appearance, their physiognomy and apparel, had come, increasingly, to resemble that of men.

This had resulted in a reconceptualization of the female portrait, wherein the decorative aspect gave way to the appearance of a thoughtful, active, and purposeful New Woman. Such a subject is exemplified in Degas' *Portrait of Mary Cassatt*, in which the female protagonist is shown with her arms resting on her thighs, her fingers fidgeting with some playing cards and a pensive, serious expression on her highly particularized face (fig. 30). Dourly dressed in black outdoor clothing, bonnet and collar secured with a knotted bow, Cassatt embodies modernity in the forward orientation of her body as well as her sensible costume and restless hand movements. Her figure is not oriented toward a viewer but is positioned at an angle, the expanse of her black costume (like that of Manet's Zola) occluding her body and prohibiting

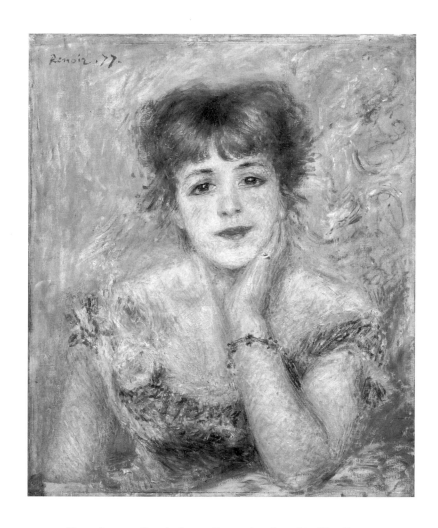

29 Pierre-Auguste Renoir, *Jeanne Samary in a Scoop Neckline Dress*, 1877
Oil on canvas, 56 × 46 cm
Pushkin Museum of Fine Arts, Moscow. Photo credit: Scala / Art Resource,
New York; reference ART9491

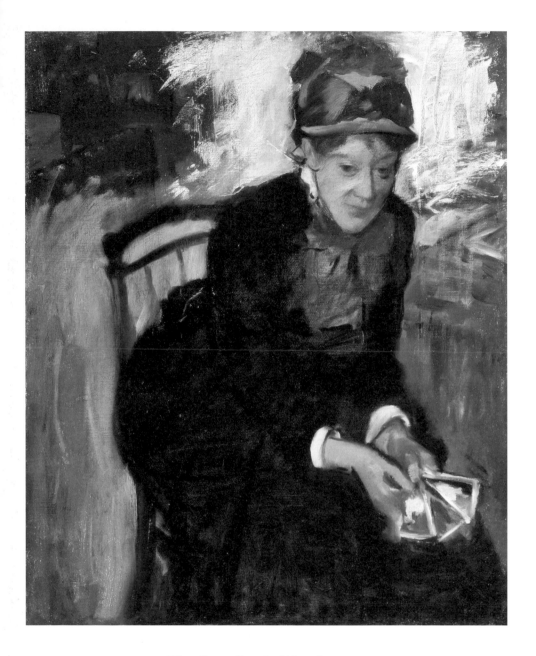

30 Edgar Degas, *Portrait of Mary Cassatt*, ca. 1880–84
Oil on canvas, 74 × 60 cm
National Portrait Gallery, Smithsonian Institution, Washington, D.C. Photo credit:
National Portrait Gallery / Art Resource, New York; reference ART67352.

access, while her downcast eyes and serious expression suggest thought and sobriety rather than absentminded reverie or mindless musing. Nor is the figure situated amongst meandering paths, mirrored reflections, or soft-focus glades. Rather, she seems to occupy the world of paint, the roughly sketched-in interior hinting at the presence of prints or books behind her without delineating or describing the setting as such. Standing out as a darkened silhouette against the painterly profusion of the surface, she cuts a solitary but replete figure: respectable, contained, and completely autonomous.

It was this new social type that was to be seen in many female portraits of the late nineteenth century. Eschewing ball gowns and depicted in simple costumes and poses which emphasized the intense expressiveness of hands and faces, women were often clothed in black and white, like their male counterparts, and presented in a sober and subdued manner. Female portraits were no longer predominantly conceived of as decorative "tableaux," but had increasingly come to be viewed as "intimate documents," analytical and psychological statements that revealed the thoughts and character of their female subjects. Women, as Mauclair put it, having been previously painted by lovers, were now to be studied by equals, their souls, rather than their flesh, the subject of a new development in portraiture.

Despite the fact that Mauclair's analyses of the transformations within portraiture were themselves a product of fin de siècle gender ideology (it is hard to see his hystericization of femininity as any less phantasmatic than his construction of Woman as a blank slate onto which men would inscribe their desires), he was one of the first critics to try to describe what was a real shift in representational codes and to ascribe this shift to the appearance of an emergent social type, the "femme nouvelle."[8] This term (a French version of the New Woman who had first appeared in Anglo-American circles in the 1880s) came to be used in the 1890s to characterize those mainly middle-class women who sought to redefine their roles as women and wives by asserting their own intellectual and professional independence and campaigning for the improvement of women's social and political status. Philanthropists, artists, writers, teachers, or society women with a conscience, the acceptable face of the New Woman came to be identified with assertive, independent creatures whose domain included that of the family and the home, but who redefined this social space as an arena in which to express themselves more fully and from which they could orchestrate their professional, intellectual, and social projects. The new definitions of femininity associated with the textual construction of the "femme nouvelle," adumbrated in journals and revues throughout the 1890s, involved a rethinking of women's physical appearance

and psychological presence, with portraiture functioning as one of the representational arenas for a new conceptualization of the feminine. As much a visual as a verbal construct, the New Woman came to be recognized as the subject of much modern portraiture, which in turn formed the site for the articulation of a subjectivity in the process of taking shape.

Exactly two years after Mauclair's long and revealing essay on women in modern painting, the critic Marius-Ary Leblond renewed the subject in an important article, published in *La Revue* in 1901 and entitled "Les Peintres de la femme nouvelle."[9] Leblond set out to define the New Woman as a creature who, unlike her predecessors, lived a full and abundant internal life, equal in intensity and commitment to that of a man.[10] He saw modern women as divided into two types: those who had been affected by modern technological inventions and the speed and dynamism of metropolitan culture, and who therefore displayed a new alertness, a nervous energy and mobility in their personas, bringing to the domestic interior "something of the street"; and those who, having been sequestered from the street by social position or family restrictions, were meditative and reflective. Silent and soulful, these women seemed troubled by intense thoughts and social preoccupations. Whether of the first or second type, Leblond's conception of the "femme nouvelle" was of a privileged woman, an *haute bourgeoise* who presided over her salon with energy and authority, enjoying the female company she gathered around herself and sharing intellectual and cultural pursuits with her friends at home. Educated, intelligent, and literary in her aspirations, she eschewed fashion and finery for what Leblond called "the toilette of talk," the "fine lace of psychology," "the jewellery of words," and the "beautiful linen of friendship."[11] Committed to simplicity and sobriety, she rejected extravagant showiness and ostentatious display for a democratizing, demure modesty that frequently made her costume resemble that of a female worker. She participated in a new social grouping in which all women were free, refined, intellectual, and artistic, and in which women lived autonomous social lives, devoid of excess luxury and free of the constraints of high fashion. Physically and socially comfortable, at ease with herself and her companions, and engaged in worthy pursuits, the "femme nouvelle," in Leblond's conception of her, had redefined her domain, the interior, and made it a space of productive intellectual and artistic engagement equivalent to the *cercles* and clubs frequented by men. Where the interior had, as numerous modern life paintings by women artists such as Mary Cassatt and Louise Breslau testify, been conceived of throughout the nineteenth century as a space in which women engaged in amateur handicrafts and "women's

work" within familial and exclusively female social spaces, the construct of the New Woman, as Leblond imagined it, infused such traditionally female spaces with an energy born of the street and a cast of characters drawn from the circuits of an emancipated metropolitanism.

Doubtless, Leblond's conception of contented new women ruminating in their interiors is an idealized and exceedingly palatable vision, one which paints a picture of a satisfied sorority of high-minded women united in serious pursuits. Arguably, it is the same vision that Louise Breslau adumbrated in her successful Salon paintings of the 1880s, which represented women busily working at embroidering, painting, or writing in exclusively female social groups situated in domestic interiors. *At Home or Intimacy*, for example, is a double portrait of the artist's mother and sister that shows two highly individuated figures in a telling domestic setting (fig. 31). *Les Amies* depicts Breslau working at the easel on the right, accompanied by her roommates, Sophie Schaeppi and Maria Feller (fig. 32).[12] The pensive interiority of the figures, their meditative poses and air of self-absorption, their demure costumes, as well as the professional props and writing accoutrements that surround them, establish their social identities as modern women making productive and appropriate use of their time.

But the construction of the New Woman as a purposeful, engaged creature functioning effectively within the domestic domain is a far cry from her popular construction as the feminist harpy who strays perilously beyond the hearth, beloved of the caricaturists of the 1890s. Indeed, political feminists and activists had been far from content with drawing room debates and polite protestation, and the 1890s was a decade of unprecedented public campaigning and agitation on the part of feminist and women's organizations that culminated in the international feminist congresses of 1892, 1896, and 1900, and the formation of various societies and pressure groups aimed at ameliorating women's social position, gaining political rights for women, and achieving equal access to educational institutions.[13] The political feminist, certainly a representative of the "femme nouvelle," but one less easily appropriated into bourgeois social norms and gender divisions than the figure of the soulful artiste or introspective dreamer, was widely characterized as an emasculating harridan, replete with cigarette, bicycle, culottes, and cravat (fig. 33). A public figure, dressed in pseudo-masculine clothing (culottes being a sign of a femininity spurned), she buys her freedom at the expense of her oppressed husband and bawling children. Her assertion of independence leaves chaos and confusion in its wake. Guilty of neglecting her offspring when she procreates, or of depleting the declining population of the Fatherland when she does

31 Louise-Catherine Breslau, *At Home or Intimacy,* 1885

Oil on canvas, 127 × 154 cm

Musée d'Orsay, Paris. Photo by Jean-Pierre Lagiewski. Photo credit: Réunion des

Musées Nationaux / Art Resource, New York; reference ART315935

32 Louise-Catherine Breslau, *Les Amies*, 1881
Oil on canvas, 85 × 160 cm
Musée d'art et d'histoire, Ville de Genève; acc. no. 1883-2.
Photo credit: Bettina Jacot-Descombes

33 "Revendications féminines," *Le Grelot*, 19 April 1896

not, the feminist, in the popular imagination, was an unwomanly aberration whose freedom was bought at the expense of the rest of society. Forward and presumptuous in her sexual as well as her social behavior, the "emancipated woman," replete with cigarette, portfolio, and masculine headgear, would, the caricaturists quipped, eventually be picking up men, seducing the reluctant creatures, and paying them for their services in a turn of events destined to throw society into total disarray.

The pictorial construction of the feminist as a deviant or unwomanly woman was by no means new. The pretensions of the emancipated woman, most often figured as an unnatural creature who had usurped men's roles at the expense of her feminine charms and maternal duties, had been a figure of fun and a target for the caricaturist's wit since the 1840s, when the terms of her satirization had been firmly established. Men such as Daumier, Grandville, and Gavarni had all played a part in an iconographical construction of the female intellectual, writer, or artist as a social aberration and a pictorial eyesore. Most extreme amongst these were Daumier's "bas bleus" or bluestockings, an army of unnatural shrews whose intellectual pretensions were matched by an abdication of all maternal feeling and wifely responsibility, as well as a renunciation of fashion, self adornment, and attention to personal appearance.[14] Daumier's women with literary aspirations are invariably shown as skinny and unattractive, their philosophical pretensions and intellectual endeavors deemed incompatible with physical beauty or health. Denatured by their aspirations, they appear aberrant, sexless, and foolish. Reneging on domestic duties, such as mending their emasculated husband's trousers or tending to the needs of their children, they selfishly pursue their intellectual goals, appearing as unnatural usurpers of masculine roles who have become desexualized in the process.

Women artists with professional aspirations were also regarded as figures of fun. Conventionally associated with the muse or model, the woman artist, having vacated her traditional place as source of inspiration in order to occupy the position of inspired creator, was vulnerable to mockery and satire. In one mid-century engraving, for example, entitled "Songez que vouse peignez l'histoire" (Remember that you are painting history), an older male teacher peers lasciviously over the easel of a young woman artist faced with the impropriety of rendering the male nude. The juxtaposition of female artist and male model provided particular material for a jest in which both the body of the model and the artist in question are less than ideal. The notion of a woman artist empowered to scrutinize the body of a naked male allowed

ample opportunity to deflate her pretensions or sexualize the encounter in such a way that Art itself seemed threatened.[15]

Actual women artists, especially those who transgressed the boundaries of amateurism and accomplishment that art deemed appropriate to women, had to negotiate a number of social types and representations in their self-fabrications. Normative representations of the woman artist sequestered her safely in the domestic interior, where the nursery could double as a studio and the easel sat comfortably alongside needlework, childcare, and female companionship (fig. 34). Accustomed to the idea of art as a refined pastime for well-adjusted wives and daughters, the woman artist was also acutely aware of the ways in which her serious aspirations could be made an object of humor and used to ridicule her in the public eye. Caricatures of women students (and sometimes their male teachers) produced at the Académie Julian in the 1870s demonstrate the continuing strategy of deflating women's ambitions by satirizing their appearance. Anonymous satirical sketches of women students at the Académie drew on well-tried stereotypes of deformed physiques and unflattering profiles. Either too skinny through overwork and over-concentration, or entirely lacking in shape or grace, these caricatures of women artists routinely poked fun at their physical characteristics and rendered them deformed or unattractive.

Even the stylish aristocrat and successful painter, Marie Bashkirtseff, was not immune to such characterization, as evinced by images of her produced in 1878 and 1879 at the Académie Julian showing an inflated behind, exaggerated waist, and vulgar gestures (figs. 35, 36). Bashkirtseff's famous journals from this period were filled with agonizing reflections on her own appearance and an anxiety that her talent as an artist would unsex her as a woman. Painfully aware of the construction of the ambitious woman artist as one who had reneged on her role as a feminine woman, Bashkirtseff constantly compared herself to other women in terms of her physical attributes and social skills.[16]

Women's traditional role, as objects to be adorned, surfaces to be painted and embellished, whether in the flesh or on canvas, according to the dictates of style and fashion, had made them, as Mauclair put it, a tabula rasa onto which an infinite number of dreams could be projected. Such a construction of femininity was incompatible with the image of forthright professionals taking the brush into their own hands.

Powerful portraits of women artists in nineteenth-century France, therefore, are few and far between, and self-portraits are extremely rare. Despite the appearance of fashionable women at the easel in many modern jour-

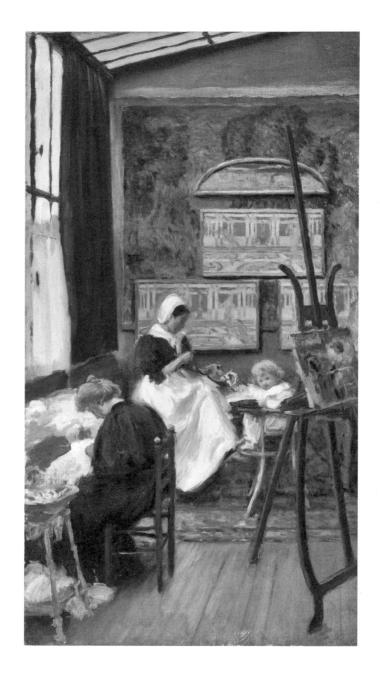

34 Mary Fairchild, *In the Nursery—Giverny Studio*, ca. 1897–98
Oil on canvas, 81.3 × 43.2 cm
Danie Collection, Terra Foundation for American Art, Chicago; acc. no. 1999.91.
Photo credit: Terra Foundation for American Art / Art Resource, New York;
reference ART188730

1878

35 Artist unknown, *Mlle Marie Bashkirtseff*, 1878
Pencil sketch; caricature from the album *Croquis de Mme Geraldi*
Collection of André del Debbio, Paris

1879

36 Artist unknown, *Mlle Marie Bashkirtseff*, 1879
Pencil sketch; caricature from the album *Croquis de Mme Geraldi*
Collection of André del Debbio, Paris

nals and family magazines, it was as accomplished amateurs that they were admired and promoted. In this context, the two bold and forthright images with which I started this essay, one a self-portrait, the other a portrait by a female painter (Anna Klumpke) of a successful woman artist, are particularly interesting.[17] Each could be said to embody the qualities of the New Woman and to eschew women's traditional function as decorative objects framed by and in relation to masculine desire and conventional gendered representational codes. A remarkable precedent for these works is the assertive self-portrait produced by the American painter Ellen Day Hale during her second stay in Paris in 1885 (fig. 37).[18] In an unusually confrontational and frontal self-representation, Hale provides no personal or professional clues to her identity, but asserts a sentient and assured subjectivity through a direct and forceful gaze and a pared down and plain self-fashioning. Although sartorial accessories are present, and the costume is undoubtedly feminine, the trimmed fringe, subdued framing hat, unadorned features, and forthright expression construct a peculiarly androgynous figure, positioned in a shallow and unrelenting pictorial space. A New Woman indeed, the physical construction of the figure and composition, along with the overt painterly references to the realists Manet and Courbet, makes this an unusually assertive image for a nineteenth-century woman artist, one which seems to de-sex its subject even as it proclaims her authority. Pictorial constructions of the New Woman, as conceived by Mauclair and Leblond, took no account of the complex and often painful negotiation of representational codes that the assertion of women's newfound subjectivity had entailed for women themselves. For women artists, the self-possession and professional assertiveness that portraits like these managed to muster was also a refusal to be represented by the terms of the dominant culture.

Both Anna Bilinska-Bohdanowiczowa and Rosa Bonheur were familiar with the image of the woman artist as a figure of fun. Bonheur, who cut an unlikely figure with her transgressive, masculine costume and characteristic uncoiffed hair, had suffered many indignities at the hands of the caricaturists and satirists in her life. In a little drawing entitled "Medaille d'Honneur et le Bouguereau des vaches," the caricaturist Guillaume, for example, exaggerated her features to produce the image of the "hommesse" so feared by politicians and social theorists alike. So dangerous was the "manly woman," in the view of the authorities, that women were, at the time, forbidden from dressing as men, and Bonheur herself had to obtain an official certificate to allow her to wear her characteristic smock and trousers when working.[19] But Bonheur was supremely self-conscious about her own self-presentation and determined

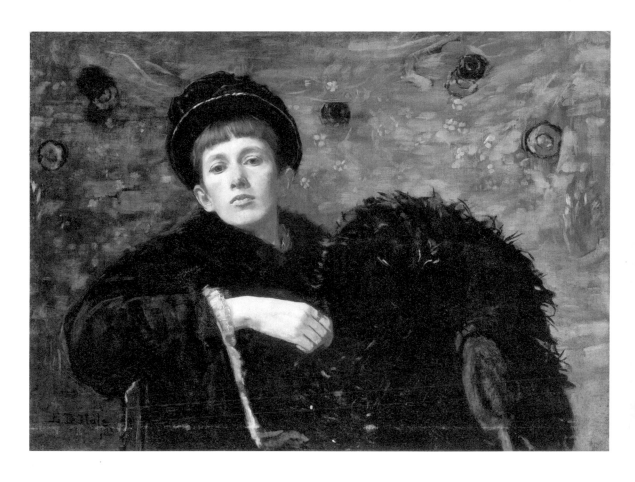

37 Ellen Day Hale, *Self-Portrait*, 1885
Oil on canvas, 72.39 × 99.06 cm
Museum of Fine Arts, Boston; gift of Nancy Hale Bowers.
Photo credit: Museum of Fine Arts, Boston

always to dress "en femme" for official portraits and photographs. An early portrait photograph by Eugène Disderi, for example, shows her elaborately gowned and conventionally posed in the photographer's studio (fig. 38). But Bonheur was not past poking gentle fun at her own figure in her private correspondence, as a tiny sketch of herself hunched in front of her easel indicates.

Perhaps one of the most tellingly self-conscious self-parodies by a woman artist of the period is Bilinska-Bohdanowiczowa's inclusion of a tiny sketch of herself painting at the easel in the top left-hand corner of her extraordinary *académie* of 1885 (fig. 39). With the exaggerated profile and ungainly posture that was the stock-in-trade of caricatures of women artists of the time, the smocked figure of the painter at her easel haunts the edge of this highly accomplished figure study, asserting her skill in handling the controversial and forbidden subject of the male nude, as well as her awareness of the image of herself which such an endeavor provoked. Included in the painting on the right-hand margin are two satyrlike male figures who seem to suggest the sexual frisson that the encounter between the female artist and the male model was thought to provoke. The artist includes her own caricatural construction of herself in her ambitious académie. In this witty piece of self-mockery, she simultaneously reveals the cultural stereotype of the woman artist and undermines its power by demonstrating, on the same surface, her skill at handling the most forbidden of genres.

When Bilinska-Bohdanowiczowa came to produce her own self-portrait two years later she rendered her features with extraordinary veracity (see fig. 19). The lines on her forehead, the unplucked eyebrows and shadows under the eyes, the determined mouth and forthright chin, all defy conventional notions of female prettiness or the demands of idealization to which society portraits adhere. The dirty brushes, glistening with oil paint as they lie in her carefully delineated hand, furnish her with the tools that make her labor apparent. An embodiment of the New Woman, possessed of an inner life as well as a social identity, Bilinka's self-image rejects the idea of woman as spectacle, in favor of a construction of femininity that is self-assertive and assured.

Such assurance is more ambivalently staged in her contemporary Marie Bashkirtseff's *Self-Portrait with a Palette* of 1883 (fig. 40). A successful figure painter who was already widely acclaimed during her lifetime, Bashkirtseff had produced an ambitious image of the women's studio of the Académie Julian in 1881, but had chosen to exhibit it under the pseudonym Mlle Andrey. In it, a group of women artists is seen to be working from the

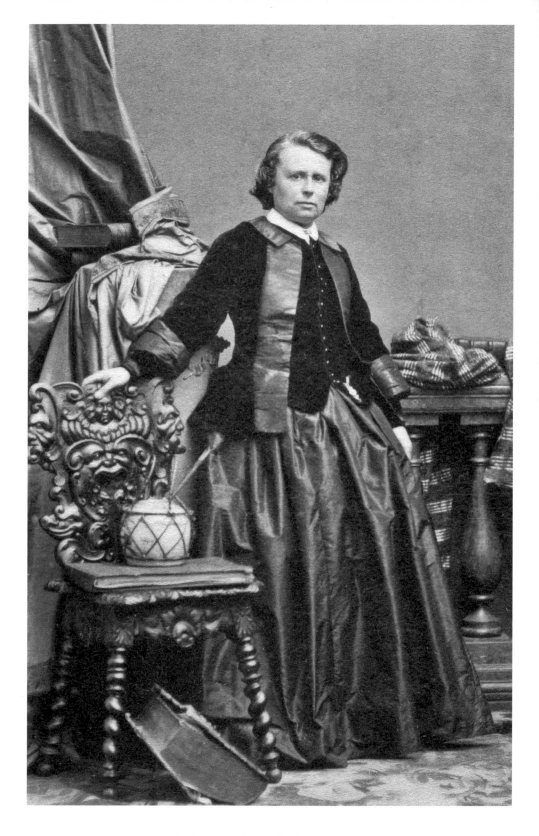

38 Eugène Disderi, *Rosa Bonheur*, ca. 1865
Photo credit: Adoc-photos / Art Resource, New York; reference ART305498

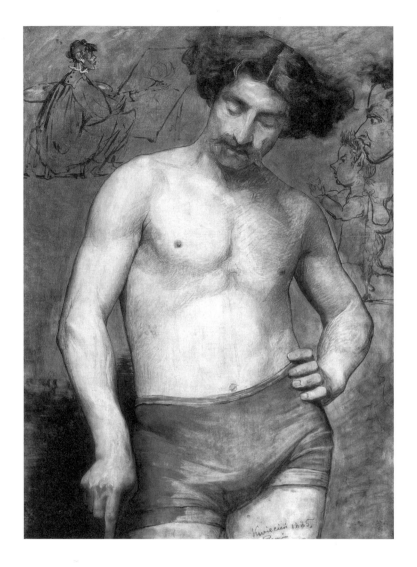

39　Anna Bilinska-Bohdanowiczowa, *Male Semi-Nude Study*, 1885
Oil on canvas, 95 × 67 cm
Collection of the National Museum in Warsaw,
Inv. MP 1986. Photo credit: Teresa Żółtowska-Huszcza

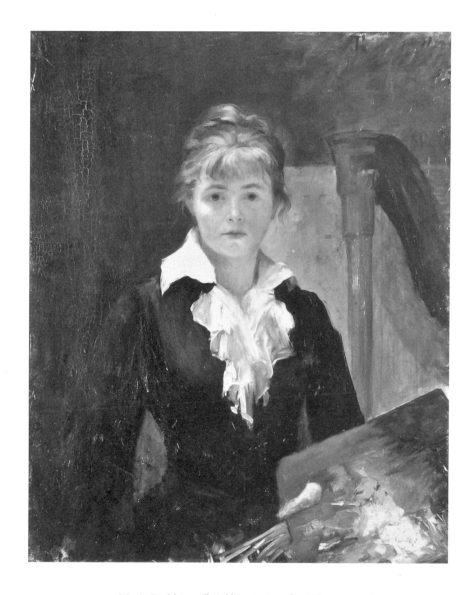

40 Marie Bashkirtseff, *Self-Portrait with a Palette*, ca. 1883
Oil on canvas, 92 × 73 cm
Musée des Beaux-Arts (Jules Cheret), Nice

male model, albeit a draped child, and functioning in a milieu that is both communal and purposeful. Interestingly, this image was used on the cover of the conservative art journal *L'Art français* in 1893[20] (fig. 41). Working in oils, as indicated by the woman armed with palette and brushes in the front, surrounded by sketches, reproductions, and even a fragment of the manly *Le Figaro*, the women, dressed in serviceable clothes and aprons, are shown to be seriously engaged with their labor in an atmosphere of calm concentration.

Such sobriety and quietude is also apparent in Bashkirtseff's self-portrait, her simple costume, unadorned person, and laden palette, placed directly in the front of the picture plane, affirming her identity as a painter who wishes to be taken seriously. Yet, included in the back of the picture is a curiously placed harp, conventionally associated with the accomplishment and refinement of a young society woman. In the case of the image of a woman artist, the harp's presence deflates the palette's power to signify professionalism. This portrait functions, therefore, as a telling document of the complex negotiations that the late nineteenth-century woman artist had to make. Imbued with an interiority and a consciousness that encounters the viewer head on, somber in tone and sober in overall effect, the image Bashkirtseff fabricates is of herself as a modern woman, claiming her right to an autonomous subjectivity and the power to project it as Art, but securing her womanliness by including an instrument firmly gendered in the feminine.[21] This is a different strategy of self-representation than that of the radical suffragist (a role Bashkirtseff assumed in secret) who donned a wig and a disguise to attend meetings at the home of the notorious suffragette, Hubertine Auclert. Neither does this reveal her as the art critic Pauline Orell, the pseudonym that Bashkirtseff assumed when she wrote vigorous campaign letters to gain women's access to the Ecole des Beaux-Arts, letters that she published in the pages of the outspoken suffragist paper, *La Citoyenne*. An oil painting, a portrait of an artist and a woman, the image constructed by Bashkirtseff in the self-portrait is both assertive and palliative, both novel and highly traditional. Like the category of the New Woman itself, it is not a description of a real woman, but rather constitutes a textual or representational construct that functions discursively as a rejoinder to and dialogue with the topoi of femininity of which the culture was made.

Perhaps it is this image that most tellingly reveals the tensions and anxieties surrounding the ascription of consciousness, even autonomy, to modern women at the turn of the century. At a time when women's social and political position was not significantly better than it had been throughout the century,

Septième année. — N° 318.

LE NUMERO : **40** CENTIMES

SAMEDI 27 MAI 1893

L'ART FRANÇAIS

REVUE ILLUSTRÉE HEBDOMADAIRE

Directeur :

H. GALLI

Bureaux : *76, Passage Choiseul, à Paris*

Rédacteur en chef :

FIRMIN JAVEL

ABONNEMENTS. — PARIS & DÉPARTEMENTS : un an, **20** francs ; six mois, **10** francs. — UNION POSTALE : un an, **24** francs, six mois, **12** fra

Les ateliers de Femmes

Le tableau de la regrettée Marie Bashkirtseff : *A l'atelier Julian*, que nous publions aujourd'hui, a figuré au Salon de 1881. Il était signé « *Andrey* ». En effet, la charmante artiste, si prématurément enlevée à l'affection des siens, n'a abordé le Salon sous son vrai nom qu'en 1883 avec un tableau : *Jean et Jacques*, et deux portraits au pastel.

Cet *Atelier Julian* a son histoire, que Marie Bashkirstseff a contée elle-même dans son *Journal.*

« *Vendredi 24 décembre 1880.* — Ayant fait de mauvais rêves, je vais à l'atelier où Julian me fait l'offre suivante : Promettez-moi que le tableau sera à moi et je vous indiquerai un sujet qui vous donnera la célébrité ou au moins la notoriété de six jours, après l'ouverture du Salon. » Naturellement, je promets. Il tient le même langage

A L'ATELIER JULIAN

à A., et après nous avoir fait écrire et signer l'engagement, avec Magnan et Madeleine pour témoins, moitié riant, moitié sérieux, il nous emmène dans son cabinet et nous offre, à moi, de faire un coin de notre atelier avec trois personnes sur le premier plan, grandeur nature et d'autres comme accessoires, et à A., tout l'atelier de la rue Vivienne, 55, en petit.... Quant au sujet il ne me dit pas beaucoup, mais ça peut être très amusant, et puis Julian est si empoigné, si convaincu : il m'a cité tant d'exemples qui ont réussi — jamais un atelier de femmes n'a été fait... Du reste, comme ce serait une réclame pour lui, il ferait tout au monde pour me donner cette fameuse notoriété dont il parle. Ce n'est pas facile un grand machin comme ça... Enfin, nous verrons ».

C'est sur ce ton familier que la pauvre enfant dira, au jour le jour, ses joies et ses angoisses, selon un mot encourageant ou une critique de ses pro-
fesseurs. MM. Tony Robert-Fleury et Julian, et l'on constatera avec regret

» Julian trouve qu'il a énormément gagné depuis huit jours, que c'est maintenant.

» Tony n'a pas vu le changement du centre ; les trois principales fig quoique au second plan sont repeintes, changées, et puis d'autres, et mains.

» Je sens moi-même que c'est mieux à présent, nous verrons ce que demain Tony

» Il y a en seize personn le squelette, fait dix-sept..

Le lenden les maîtres ne pas satisfaits Marie Bashkir s'écrie :

« Ah ! je drais qu'il crevé, ce tal pour ne pas forcé de l'exp Et il y a là démie du m un petit bon me de dix Non, si j'av ça comme de la sem j'aurais gratt c'est mal c tout d'un commun, sa ractère et a ment indig moi : c'est l mauvais de bleaux. »

A l'atelier obtint au co au Salon, u joli succès d'

et c'est ce qui décida la jeune artiste à adopter, dès l'année suivante, sa ture patronymique. Al'époque où cette toile intéressante révéla au publi térieur d'un atelier de femmes, il n'y avait guère, à Paris, outre l'Aca Julian, que l'atelier fondé par MM. Carolus Duran et Henner où les f peintres fussent assurées de recevoir les leçons les plus sérieuses. Cette d'annexe à l'école de beaux arts était située quai Voltaire, à deux l'*autre.* De là sont sorties, notamment, Mmes Lee Robbins, dont on succès au Champ-de-Mars, et Mlle Forget, la seule artiste femme qui ait une commande pour la décoration de l'Hôtel de Ville. Aujourd'hui l Carolus Duran et Henner n'existe plus, mais les femmes trouvent enc excellent enseignement à l'atelier Henri Gervex, dont la surveillance e fiée à Mlle Valentino, à l'atelier Hector Le Roux, à l'atelier Krug, et ateliers sont de précieuses ressources pour ces intéressantes élèves, d mieux que l'école des Beaux-Arts leur reste impitoyablement fermée.

41 Cover of *L'Art français*, 27 May 1893

the category of the New Woman was a fragile and fraught construction, one that was as much a projection of a fantasy of female empowerment, yet still institutionally enshrined, as an attempt to alter the terms of female representation inherited from the past. Portraits of women offer one of the sites of this negotiation.

NOTES

TEMPORALITY & THE DANCER

1 I first began to work on Degas' representation of the ballet and its pro-
tagonists when I received an invitation to speak at the conference orga-
nized to coincide with the important exhibition "Degas and the Dance"
held at the Philadelphia Museum of Art in 2002. I am grateful to Richard
Kendall and Jill de Vonyar for the invitation and for the indispensable
research in their catalogue, *Degas and the Dance* (New York: Harry N.
Abrams, 2002). I am indebted as well to the important scholarship of
Carol Armstrong, *Odd Man Out: Readings of the Work and Reputation of
Edgar Degas* (Chicago: University of Chicago Press, 1991). The oppor-
tunity to speak about the ballet pictures as one of the Murphy lectures
has enabled me to revise and revisit my earlier lecture.

2 Paul Mantz, *Le Temps, 1877,* quoted in Armstrong, *Odd Man Out,* 38–
39.

3 For reproductions of such images, see de Vonyar and Kendall, *Degas and the Dance,* 20–27.

4 See Lynn Garafola, ed., *Rethinking the Sylph: New Perspectives on the Romantic Ballet* (Middletown, CT: Wesleyan University Press, 1997), 6.

5 Marc de Montifaud, *L'Artiste,* 1 May 1874, quoted in Charles S. Moffet, *The New Painting: Impressionism 1874–1886* (San Francisco: Fine Arts Museum of San Francisco, 1986), 141.

6 The literature on Realism is vast. A useful recent contribution to debates on literary and visual realism in the nineteenth century is Peter Brooks, *Realist Vision* (New Haven: Yale University Press, 2005). Earlier works that I have found indispensable include Erich Auerbach, *Mimesis: The Representation of Reality in Western Literature,* trans. Willard R. Trask (Princeton: Princeton University Press, 1953), and Linda Nochlin, *Realism* (Harmondsworth, UK: Penguin, 1971).

7 For more on this pastel and a comparison with a contemporary engraving of the interior of the building, see de Vonyar and Kendall, *Degas and the Dance,* 16–18.

8 For a discussion of the use of fragmented body parts in Degas' dance pictures, see Armstrong, *Odd Man Out,* 128–33.

9 See John V. Chapman, "Jules Janin: Romantic Critic," in Garafola, *Rethinking the Sylph,* 197–212, for more on Janin's views.

10 Quoted in Ivor Guest, *The Romantic Ballet in Paris* (Middletown, CT: Wesleyan University Press, 1966), 21.

11 Abigail Solomon-Godeau discusses the commodification of women's bodies in nineteenth-century print culture in "The Other Side of Venus: The Visual Economy of Feminine Display," in *The Sex of Things: Gender and Consumption in Historical Perspective,* ed. Victoria de Grazia and Ellen Furlough (Berkeley: University of California Press, 1996), 113–50.

12 For a discussion of the fragment as representative of the modern, see Linda Nochlin, *The Body in Pieces: The Fragment as a Metaphor of Modernity* (London: Thames & Hudson, 2001).

13 A discussion of legs in the context of the fetishization of the female body in late nineteenth-century France can be found in Abigail Solomon-Godeau, "The Legs of the Countess," in *Fetishism as Cultural Discourse,* ed. Emily Apter and William Pietz (Ithaca: Cornell University Press, 1987), 266–306.

14 Marc de Montifaud, quoted in Armstrong, *Odd Man Out,* 52–53.

15 Paul Valéry, *Degas, Danse, Dessin* (Paris: Gallimard, 1965), 27.

16 For the gender implications of Mallarmé's theories of the dance, see Julie Townsend, "Synaesthetics: Symbolism, Dance, and the Failure of Metaphor," in *The Yale Journal of Criticism* 18, no. 1 (2005): 126–48. See also Dee Reynolds, "The Dancer as Woman: Loïe Fuller and Stéphane Mallarmé," in *Impressions of French Modernity: Art and Literature in France 1850–1900,* ed. Richard Hobbs (Manchester: Manchester University Press, 1998), 155–72.

17 Valéry, *Degas, Danse, Dessin*, 138–40.

18 For a useful discussion of the way in which the marks of drawing exceed their descriptive function and cannot be reduced to signs, see James Elkins, *On Pictures and the Words That Fail Them* (Cambridge: Cambridge University Press, 1998), 3–46.

PORTRAITURE & THE NEW WOMAN

1 A lengthy discussion of nineteenth-century female portraiture in the context of gender, genre, and narrative can be found in Tamar Garb, *The Painted Face: Portraits of Women in France, 1814–1914* (New Haven: Yale University Press, 2007).

2 For a detailed discussion of the iconography of this painting, see Theodore Reff, "Manet's Portrait of Zola," *The Burlington Magazine*, 117, no. 862 (1975): 34–44.

3 Camille Mauclair, "La femme devant les peintres modernes," *La Nouvelle revue,* 2nd ser., 1 (1899):190–213.

4 Mauclair, "La femme devant les peintres modernes," 193.

5 For a discussion of this picture's reception, see Tamar Garb, "Framing Femininity in Manet's Portrait of Mlle E. G.," in *Self and History: A Tribute to Linda Nochlin*, ed. Aruna D'Souza (London: Thames & Hudson, 2001), 77–90. For an alternative reading of the picture in relation to gender and agency see Carol Armstrong, *Manet Manette* (New Haven: Yale University Press, 2002), 175–200.

6 Mauclair, "La femme devant les peintres modernes," 204.

7 Ibid., 206.

8 For a concise and cogent discussion of the discourse on the "femme nouvelle," see Debora L. Silverman, *Art Nouveau in Fin-de-Siècle France: Politics, Psychology, and Style* (Berkeley: University of California Press, 1989), 63–74. For a more recent elaboration of these issues, see Mary Louise Roberts, *Disruptive Acts: The New Woman in Fin-de-Siècle France* (Chicago: University of Chicago Press, 2002).

9 Marius-Ary Leblond, "Les peintres de la femme nouvelle," *La Revue*, 39 (1901): 275–90.

10 See Leblond, "Les peintres de la femme nouvelle," 276.

11 See ibid., 285.

12 See Jane R. Becker, "Nothing Like a Rival to Spur One On — Marie Bash-kirtseff and Louise Breslau at the Académie Julian," in *Overcoming All Obstacles: The Women of the Académie Julian*, ed. Gabriel P. Weisberg and Jane R. Becker (New York: Dahesh Museum; New Brunswick: Rutgers University Press, 1999), 93.

13 For a discussion of wider feminist campaigns in the period in the context of women's art production, see Tamar Garb, *Sisters of the Brush: Women's Artistic Culture in Late Nineteenth-Century Paris* (New Haven: Yale University Press, 1994), 42–69.

14 See Janis Bergman-Carton, *The Woman of Ideas in French Art, 1830–1848* (New Haven: Yale University Press, 1995), 65–102.

15 For a dramatization of this theme in one late nineteenth-century text, see Tamar Garb, "The Forbidden Gaze: Women Artists and the Male Nude," in *The Body Imaged: The Human Form and Visual Culture since the Renaissance*, ed. Kathleen Adler and Marcia Pointon (Cambridge: Cambridge University Press, 1993), 33–42.

16 See Tamar Garb, "'Unpicking the Seams of Her Disguise': Self-Representation in the Case of Marie Bashkirtseff," *Block* 13 (1987–88): 79–86. See also Rozsika Parker and Griselda Pollock, "Introduction" to *The Journal of Marie Bashkirtseff*, trans. Mathilde Blind (London: Virago Press, 1985), vii–xxx, and Becker, "Nothing Like a Rival to Spur One On," 69–114.

17 For a discussion of Klumpke's own career, see Britta C. Dwyer, *Anna Klumpke: A Turn-of-the-Century Painter and Her World* (Boston: North-eastern University Press, 1999).

18 See Kathleen Adler, "'We'll Always Have Paris': Paris as Training Ground and Proving Ground," in *Americans in Paris, 1860–1900*, ed. Kathleen Adler, Erica E. Hirshler, and H. Barbara Weinberg (London: National Gallery, 2006), 23–27.

19 See Dore Ashton, *Rosa Bonheur: A Life and a Legend* (London: Secker & Warburg, 1981), 57. For discussions of Bonheur and gender construction in the nineteenth century, see Albert Boime, "The Case of Rosa Bonheur: Why Should a Woman Want to Be More Like a Man?" *Art History* 4 (1984): 384–409, and James M. Saslow, "'Disagreeably Hidden': Construction and Constriction of the Lesbian Body in Rosa Bonheur's

Horse Fair," in *The Expanding Discourse: Feminism and Art History*, ed. Norma Broude and Mary D. Garrard (New York: Harper Collins, 1992), 186–205.

20 See Garb, *Sisters of the Brush*, 82–83, for the broader context of this.

21 This is in keeping with the complex strategies of mimicry and masquerade that "new" women performed in order to ensure their "femininity" while claiming their rights to participate fully in society. For a discussion of such self-representational strategies in relation to Bashkirtseff, see Garb, "Unpicking the Seams of Her Disguise." For a later discussion of the New Woman and such performative strategies, see Roberts, *Disruptive Acts*.

INDEX

LIBRARY OF CONGRESS

CATALOGING-IN-PUBLICATION DATA

Garb, Tamar.
The body in time : figures of femininity
in late nineteenth-century France
/ Tamar Garb. — 1st ed.
p. cm. — (The University of Kansas
Franklin D. Murphy lecture series)
Includes bibliographical references and index.
ISBN 978-0-295-98793-4 (pbk. : alk. paper)
1. Women in art. 2. Femininity in art.
3. Art, French—19th century.
I. Title. II. Title: Figures of femininity
in late nineteenth-century France.
N7630.G278 2008
704.9′424094409034—dc22
2008014368